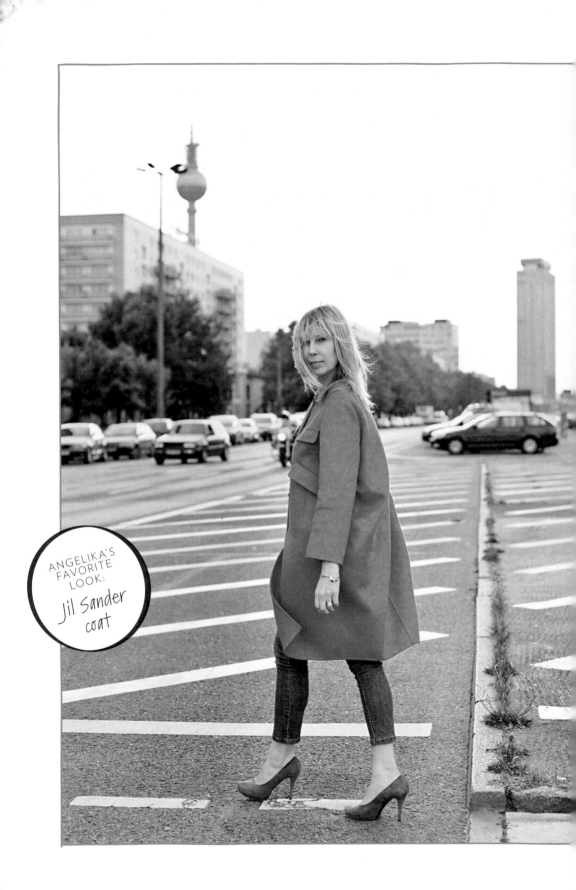

ANGELIKA'S FAVORITE LOOK: *Jil Sander coat*

# BERLIN STREET STYLE

## A GUIDE TO URBAN CHIC

BY

## ANGELIKA TASCHEN

WITH

## ALEXA VON HEYDEN

ILLUSTRATIONS BY MELANIE PETERSEN
PHOTOGRAPHS BY SANDRA SEMBURG

ABRAMS IM▲GE
NEW YORK

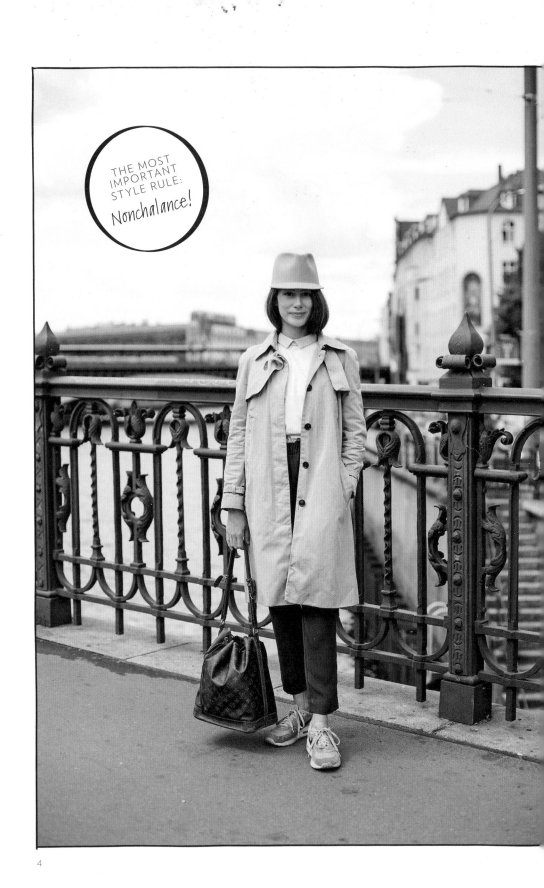

THE MOST
IMPORTANT
STYLE RULE:
*Nonchalance!*

# Contents

**PART 1**

What Berlin Is Wearing 6

**PART 2**

Naturally Beautiful 108

**PART 3**

The Berlin Woman at Home 136

**PART 4**

Angelika's Berlin 174

# What BERLIN Is Wearing

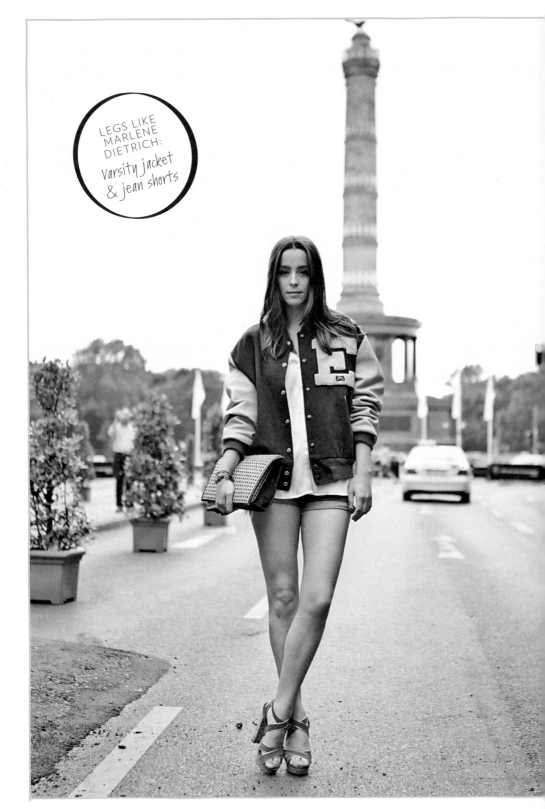

LEGS LIKE
MARLENE
DIETRICH:
*Varsity jacket
& jean shorts*

# THE "NEW"
# BERLIN WOMAN

Most Berlin women are immigrants, from other areas of Germany or from other countries entirely; I am as well. I moved from Los Angeles to the young German capital. Berlin style benefits from the fact that so many influences come together there. The new Berlin woman plucks up the best pieces for herself from international fashion events and, with these finds, creates the unforced, urban-chic style that is typical in this city.

That Certain Something 10
Favorite Outfits 12
Unforced Chic 14 · Trend No-Gos 16
These Simply Do Not Work! 20
Botox for Your Style 24

# That Certain Something

Describing Berlin style is not a simple matter. It is an eclectic look characterized by creativity and individuality. But there are a few common threads that pull together this coveted approach to fashion. For example, women spotted throughout the city rarely flaunt luxury labels; rather, the luxury is in the materials. There are also a few key essentials, which are easily spotted on every sidewalk in every area of town, and which will be covered more in the pages to follow. For instance, in this land of long and cold winters, tights advance upward on the list of must-haves for the Berlin woman, and the ability to wear them well is a trademark of a true Berliner. Below are a few traits of today's stylish Berlin woman:

## She loves the unfinished——

Look around: Something is always being built somewhere in Berlin. This "raw state" is reflected in the fashion preferences of the locals. The Berlin woman has a good eye for fine materials, but her look should never be too perfect and slick. Think of exposed seams on cashmere or silk clothes, of bleached or even holey jeans, and well-worn sturdy boots— these are details that the Berlin woman appreciates.

## She avoids huge logos——

Nothing against well-known luxury brands, but in Berlin no one is impressed with gold belt buckles or windswept logo scarves. It is embarrassing to show off wealth in such an obvious way. Why? In contrast to Frankfurt or London, Berlin is not a financial city, but rather a creative city. Artists—such as painters, musicians, designers—sometimes have money, and sometimes do not. But in any case, they value creativity and quality over pretentious names.

## She is naturally beautiful——

The Berlin woman is no tart. She doesn't smear a thick layer of makeup onto her face, or own a push-up bra or blond Rapunzel-inspired hair extensions. The Berlin woman barely needs make-up because her skin always has a rosy shimmer thanks to well-chosen cosmetic products and a healthy glow from riding her bike. And her hair? Rather than labor-intensive blow-drying and styling, she lets it air dry, of course!

## She loves blogs——

The Berlin woman primarily works in a creative occupation and will quite happily draw inspiration from blogs during her breaks, if she is not actually blogging herself. Of course, fashion is not the only enthralling subject. She is also interested in all of the related disciplines: beauty, art, design, interiors, photography, and everything that has to do with DIY!

## Her motto: Support your local merchant——

These days, it is almost exclusively the big chains that can still afford the rent in the city center, so it is all the more important to support the small, independent boutiques and local designers.

The Berlin woman knows which labels are sold where, ideally knows the owners personally, and pays a visit to her favorite stores regularly.

## Her favorite hobby is treasure hunting——

Vintage shop. Designer sale. Flea market. These are the words that make the Berlin woman's heart beat faster, because they offer the chance to snap up a bargain or uncover a stylish treasure. Often at the top of the most-wanted list: antique earrings or an unusual clutch. Accessories like these lend more personality to an outfit— and personality is the most essential accessory in Berlin.

# Favorite Outfits

When window shopping in the city center, the Berlin woman
has countless places to discover a new look for a party in
Kreuzberg or a gallery opening in Neukölln—two of Berlin's
hippest areas. She also likes to purchase trends online or
at her favorite boutique. Nevertheless, a Berlin woman's
closet is never bursting at the seams, but rather holds
the basic pieces from which she can create at least a few
outfits with ease. These are my favorite combinations!

1. *Boyfriend jeans & a slouchy white T-shirt* in a cotton-linen blend, with a white oversize jacket and black spiky slingback pumps.

2. *Norwegian pullover & leather leggings, and spiky pumps à la Louboutin—* instead of blue jeans and flat, lace-up shoes. Leather is so beautifully *rrrrr!*

3. *Trench coat, shirtdress & natural-colored, beige sandals with a cork heel—* rather than a trench coat with jeans. This feminine combination works fantastically during the Berlin summers!

4. *Army jacket & pumps in neon yellow, hot pink, or a leopard print—* instead of jeans with a blazer and ballerina flats. Berlin is no city for the typical office look.

5. *Silk evening dress & a soft black leather jacket—* instead of a bolero jacket and Pashmina scarf. Sorry, but that look is just too preppy!

6. *Smoking jacket & skinny jeans, with a white silk blouse & sparkly gold sandals—* instead of a black jacket with matching pants. The Berlin woman does not like to be too matchy-matchy.

7. *Men's shirt & jean shorts & a colored belt—* instead of little summer dresses and sandals. This is much better suited for riding a bike and hanging out in the park.

8. *Yoga pants, kitten heels & a trench coat—* instead of yoga pants, Ugg boots, and a parka. Making exercise a little bit chic does no harm. Who knows who you might meet while grabbing a coffee afterward?

9. *Sweatshirt over a blouse & a miniskirt, along with the very latest Nike sneakers—* instead of a blouse, miniskirt, and high heels. The Berlin woman does not wish to dress in the stereotypically sexy way.

# Unforced Chic

What exactly constitutes the Berlin style? It is of the utmost importance to the Berlin woman that she appears nonchalant. Need concrete examples? Here you go.

* The Berlin woman loves *elfin maxi dresses*, but in the case of accessories, the Hells Angels' style applies. So, she adds a black biker jacket, sparkly jewelry, and sturdy boots to complete her outfit.

* The Berlin woman loves *knitwear of all types*, be it the larger meshes or those little fleecy angora pullovers, so soft that they appear to be straight from a laundry detergent advertisement. For contrast, complete the outfit with extra-distressed jeans.

* Break taboos and stereotypes and make *surprising combinations*: Jogging pants (in cashmere!) and high heels, eco-pullovers with leather pants, an army parka over a party dress, a bomber jacket with a flowery Turkish scarf, or a Bavarian Trachtenjanker (military jacket) rather than a blazer—nothing is impossible.

* The Berlin woman is especially proud when she *knits her own hat*, scarf, or pullover. But those who have not mastered the knitting needles can purchase a homespun-style cap that appears as though it was knitted by hand.

* *Rolled-up* sleeves and pants legs—a blazer or denim shirt looks so much more casual that way, and a boyfriend's pullover won't look too long in the arms. In the summer, simple rolled pants cuffs will highlight both delicate sandal straps (note: the ankle is the low neckline of the Berlin woman) and high-top sneakers.

* Berlin is not a city of splashy colors. The Berlin woman will happily dress from *head to toe in black*—blue is considered colorful. Tip: Instead of only black, don muted colors (greige, taupe, mauve) in varying shades.

✳ The Berlin woman will gleefully swipe a shirt from a boyfriend or husband for herself, particularly a **white men's shirt** or a checked flannel shirt. Tip: Tuck the front part of the shirt into your jeans so that the waistband and, as the case may be, the belt are visible.

✳ The Berlin woman also loves men's or **unisex clothing and accessories**. I know couples who share parkas as well as Ray-Ban sunglasses. A men's gray sweatshirt looks super with skimpy jean shorts and sandals. Why does the look work? It takes the walk of shame look into polite company. Very sexy.

## THE GOLDEN RULE

"When too perfect, *lieber Gott böse* [God becomes evil]" was the motto of the video artist Nam June Paik. The motto has a 1:1 correlation to Berlin street style. The run in your stockings reveals red nail polish on your toes, your eyeliner is ever-so-slightly smudged, and your shoes could do with a shine? You've got it right!

✳ The Berlin woman keeps an eye out for unique clothes, jewelry, and accessories during her **travels**. I always bring handmade leather sandals back from my yearly vacation to Stromboli. Scarves from Vietnam, bracelets from Bali, clothes from Mexico—complement your closet with a little wanderlust.

✳ *Shop off the beaten track:* I will happily shop at ballet stores like Pro Danse (MITTE Alte Schönhauser Strasse 16, prodanse-shop.de) or Tanzmode Berlin (PRENZLAUER BERG Knaackstrasse 49, tanzmode-berlin.de) for strappy pumps and evening tops. Likewise, a visit to an equestrian or hunting goods shop can be worthwhile—there are often well-cut jackets and robust pullovers.

✳ The Berlin woman loves **patina**. This is particularly true for accessories. A Louis Vuitton bag need not be brand-new, for heaven's sake; boots can also appear as though they have just been danced in for a few days at a festival.

✳ The favorite hairstyle of the Berlin woman: **the bun**, also called the *chignon*. The key to this look is unwashed hair; otherwise the hairstyle will not hold. Gather the hair up from the back, twist it around, and fix it in place with a clip or transparent Blax hair elastic. It must be a little wispy.

# Trend No-Gos

The Berlin woman has seen it all: red mohawks, pierced *and* tattooed faces, women in tuxedos, and men in hot pants. Even though the city is known for its tolerance, there are style taboos. Most of all, the goal is not to appear too dressed up and posh.

## Purely functional clothing

In my eyes, there is no greater lapse in fashion than items without beauty that are simply focused on comfort or performance (e.g. brightly colored all-weather jackets, trekking sandals with Velcro fasteners, and pants that, thanks to a zipper, can be transformed into shorts).

## Panty lines

Having the shape of your underwear visible through clothing (a.k.a. panty lines) is a no-go throughout the entire world. For those who do not like thongs, there is seamless underwear made of microfiber that is invisible under clothing.

## Bra straps and push-up bras

One should never see a bra, regardless of what color it is. You do not need a push-up bra; Berlin is not a bosom city.

## Too much bling

You have earrings, a necklace, a watch, and a bracelet—if you jingle while walking, you are over-decorated. It's better to only wear one piece of jewelry. If you are wearing an extraordinary ring, forego the watch, and decide between gold or silver.

## Grandma's brooch

Vintage is adored in Berlin and if a piece inspires a good story that starts with "this comes from my great-aunt…" that's OK. But Grandma's garnet brooch on a coat lapel or a pullover can look frumpy.

## Pearls

Elsewhere, the supposed high-society women will happily wear a pearl necklace with a rose-colored polo shirt. "Pearl girls" are not at all hip in Berlin.

## Piercings

As I see it, apart from the ears, there is no other place on the body that should be pierced with metal. A bolt through the mouth simply looks ghastly.

# Too much skin

Showing too much skin can even be a faux pas when wearing a bathing suit. Think of a sunny day in the park or on the lake. Marching off to a refreshment kiosk in only a bikini and ordering an ice cream or hot dog is not done in the city or on the beach. I take a full-length tunic by Diane von Furstenberg along on vacation. By the way: In Berlin parks, while it not unusual to see people sunning themselves in the nude, it is not encouraged by law or by popular opinion.

# Belts with designer logos

Showing off with expensive luxury brands can make one cringe in Berlin—nobody will find you particularly interesting just because you have a gold *H* below your belly.

# Fakes

Phony handbags can be seen in growing numbers late in the summer when vacationers return from Turkey or Thailand. "Luis Vuitton" roller suitcases, "Bretling" watches, or "Channel" handbags… those who rely on such accompaniments and display them publicly have neither an inkling of fashion nor of quality.

# Pashmina shawls with fringes

I love India and the fine cashmere scarves that can be bought there. However, the viscose scarves with long fringe from the department store are a cheap imitation and are not anywhere near as elegant as the original.

# Cowboy boots

Even if the Berlin woman loves heeled accessories, in cowboy boots one is very quickly considered a poser. Such gaudy boots do not fit in Berlin—particularly if they're made of white python leather.

## DON'T FORGET

The most important thing above all is that you feel comfortable.

# Even More No-Gos

* *Swanky watches:* A vintage Rolex or a small Cartier is lovely, of course, but please do not wear sparkly gold watches.

* *Flip-flops:* If they're leather, there's no faux pas, but if they're rubber, I only wear them after a pedicure.

* *Backpacks:* Unless you're heading out on a hike or a world tour, backpacks are only OK for kids.

* *Colorful hosiery:* Yellow, green, or red tights will ruin every—really, every—outfit.

* *Parkas and jackets* with faux biker-gang writing on the back

* *Polo shirts,* especially with a popped collar

* *T-shirts* with supposedly clever sayings

* *Down jackets or vests* that shine like glossy paint

* *Fur boots* decorated with sequins

# 10 + 1 RULES

## These Simply Do Not Work!

# 1. Trekking sandals

Nobody requires that you totter along the East Side Gallery in high heels. But Velcro-strapped walking sandals with whiter-than-white tennis socks—this really must not happen. Big-city safaris should be made in moccasins or ballerina flats, please.

# 2. Fleece jackets and outdoorsy anoraks

When you're climbing in the Alps, fleece jackets and all-weather anoraks are undoubtedly the ideal outfit. In the city, you'll look as if you just stumbled off of a tourist bus.

# 3. Pale colors

Clothes for the elderly primarily come in these gruel-like tones, which look frightfully pallid. Avoid eggshell, oatmeal, or incorrectly mixed pastels.

# 4. Rimless glasses

It is not easy to find the perfect glasses. Materials that contrast strongly with the face look harsh, and for this reason, you should shy away from most thick-rimmed glasses. Nevertheless, rimless glasses will surely make the wearer look ten years older.

# 5. Come-hither sexy dresses

Without a doubt, a skin-tight dress is a tantalizing piece of cloth. But, could something a little more relaxed not work just as well? My suggestions are on pages 39 and 68!

# 6. Skulls

Quite a few women will happily rely on accessories with the skull motif in combination with glitter in hopes that they will come across as daring and non-conformist. Let's face it, who is still shocked by the skull and crossbones?

# 7. Funny shoes

Do you know those heels that look like amusing building blocks or those witch's shoes with the curled-up toes? Of course, fashion is a matter of taste, but such shoes seem like a cry for help.

## 8. Felt hats

You do not need to prove to anyone that you still have a
wild side despite your age—and certainly not with a felt
cap with a "witty" flower or sausage decoration. Help!

## 9. Asymmetrically cut dresses

Rather than concealing the waist and bust, loose, flowy frocks or muumuus
make a woman appear stocky and matronly, especially those made of
pleated silk. Emphasize your assets (long legs, luminous eyes, thick hair) or,
when in doubt, wear a terrific shawl to distract from any problem areas.

## 10. Saggy arms

Also called "old lady arms" or "bingo wings." Only wear sleeve-
less clothes if your upper arms are really toned—and your
model should be Michelle Obama, rather than Madonna.

## +1. Be nonchalant.

The most important rule: Be good to yourself. This
includes staying relaxed, not fiddling with yourself
too much, and not wanting to be perfect.

# 10 + 1
## RULES

# Botox
# For Your Style

# 1. Be yourself.

Do not try to look younger or present yourself as younger than you are. Authenticity is the key to good energy, which automatically keeps you young. Anything else looks desperate—and has exactly the opposite effect.

# 2. Stay natural.

Forego the thick layer of makeup; it only emphasizes any small wrinkles and enlarged pores all the more. A little blush, mascara, and lip gloss are sufficient. Dark color on the lips or eyes has an aging effect, so skip the smoky eyes and red wine lipstick. Naturalness should also apply to the hair. Steer clear of pitch-black hair dye or Barbie blond.

# 3. Drink water.

Water should be as abundantly utilized on the outside as on the inside. After washing your face or showering, a shock of cold water stimulates blood circulation and the cells are supplied with oxygen. I drink at least two liters of mineral water and have green tea every single day.

# 4. Wear sun protection.

Above all, remember on a daily basis to apply the right
SPF on the face and low neckline, as well as the back
of the hands and tops of the feet. I have forgotten this
and, unfortunately, I see it on my skin today.

# 5. Eat well.

Pay attention to your weight, but do not starve. It is not that
difficult to live healthily. But, don't just deny yourself all pleasures—
this will only put you in a bad mood. If calories are constantly
being counted, many of life's delights are being missed.

# 6. Zzzzz

Our mothers and grandmothers swear by their beauty sleep.
There is actually still nothing better for a good complexion
than eight or nine hours of restful sleep per night. The
body regenerates itself on its own during this time.

# 7. Embrace sports.

Search out what works for you. I find endurance running
and free weights fatiguing. I prefer to go to a spa, have
massages, practice yoga, or meditate. The headstand
is considered a fountain of youth by yogis.

# 8. Shun plastic surgery.

This cannot be the solution because no matter where you look, the result is always bizarre.

# 9. Dress your age.

Try not to look like your daughter or dress like her. Even if you have a bombshell figure, forego the skin-tight top and much-too-short skirt. Keep yourself in good spirits and go casual. Focus on accessories, such as a pair of fantastic high heels, great jewelry, or a glamorous handbag.

# 10. Think sexy.

It's a state of mind. Yves Saint Laurent once said, "To be beautiful, all a woman needs is a black pullover and a black skirt and to be arm in arm with a man she loves." And Françoise Sagan believed, "A dress makes no sense unless it inspires men to take it off of you." Buy yourself new lingerie—today!

# +1. Read books.

Wit and intellect demand constant input. A witty woman appears young and is never dull.

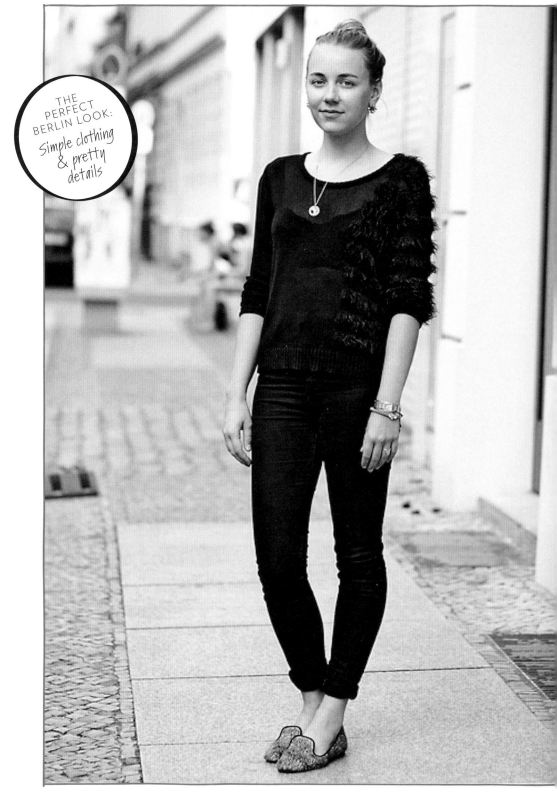

THE
PERFECT
BERLIN LOOK:
*Simple clothing
& pretty
details*

# MORE THAN BASICS

The fantastic thing about this city is that everyone here can
reinvent himself or herself over and over again. But those
who examine the Berlin woman's closet more carefully are
guaranteed to repeatedly come across the same basics
that are essential to the Berlin style. Indeed, there are
codes, clearly defined symbols and details with which
you can separate the good parka from the wrong parka.
Sometimes it is only a zipper. A small guide is included!

The Parka 30 · Jeans 32
The Blazer 34 · The Knit Pullover 36
The Leather Jacket 38
The White Blouse 40 · Sneakers 42

# The Parka

## The Berlin Look

The parka or military jacket is perhaps the most important basic piece for the Berlin woman—in the past there may have been some negative political associations with the green jacket's militaristic vibe, but no more. The parka was not even invented by the military at all, but by the natives of Siberia and Alaska. Those who have spent a winter in Berlin know: This warm, all-weather protection is essential!

## How to Correctly Style the Parka

In Berlin, one should own two parka variations: a quilted or fur-lined model for the frigid winters and a light cotton parka for the rest of the year. Feminine accessories are necessary so that one does not look like an Arctic explorer in spite of the sub-zero temperatures. Perhaps a sparkly clutch or huge Hollywood-style sunglasses.

## Please Don't!

The parka stands for the Berlin unforced, urban chic like no other piece of clothing. So please, no jackets made of shiny nylon or with rhinestone or rivet decorations on the shoulders or back. If you must have fake fur, then make it high quality. The right color is also important—it must be a muted olive and the tone must not be too yellow or green in hue.

## The Upgrade

Add sumptuous fur trim or a complete fur lining and high-quality details, such as a brass rather than a plastic zipper. Selecting a style with a drawstring means a better fit.

### THE RIGHT CHOICE

The originals are the U.S. Army Shell Parka M51 or the German Armed Forces Parka, with or without Teddy fleece lining.

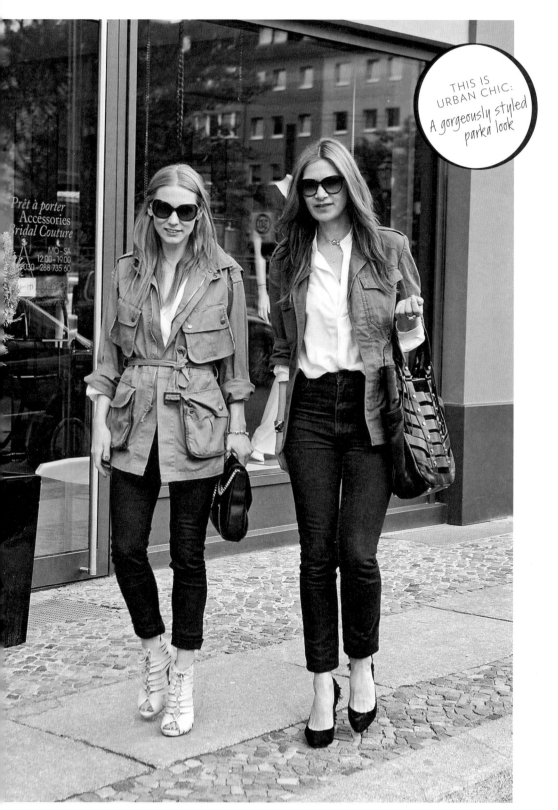

THIS IS
URBAN CHIC:
*A gorgeously styled
parka look*

Prêt à porter
Accessories
Bridal Couture

MO-SA
12.00 - 19.00
030 - 288 735 60

CLOSED

# Jeans

## The Berlin Look

You can wear jeans in Berlin around the clock and to every occasion. The skinny cut is a must for the Berlin look—it simply does not go out of fashion.

## How to Correctly Style Jeans

Finally, something that you don't have to put a great deal of thought into: Almost anything goes with jeans. However, the prerequisite is that jeans should fit very well, particularly at the knees and seat. Investing in a good pair is worthwhile, ideally one with stretch fabric.

## Please Don't!

Avoid the boot-cut style and pairs that require frequent washings or that have too many seams. A flashy logo belt, embroidered back pockets, or airbrushed details—no, no, no!

## The Upgrade

Boyfriend jeans, such as those from PRPS or Current/Elliott, paired with fancy peep-toe high heels and a short-waisted blazer.

### THE RIGHT CHOICE

Skinny jeans by Acne because they are so wonderfully simple, without unnecessary seams or big logos. With time, the denim adapts itself to the body. You should have pairs in dark blue, medium blue, and black in your closet. A pair of black skinny jeans with high heels and a tuxedo blouse looks great in the evening.

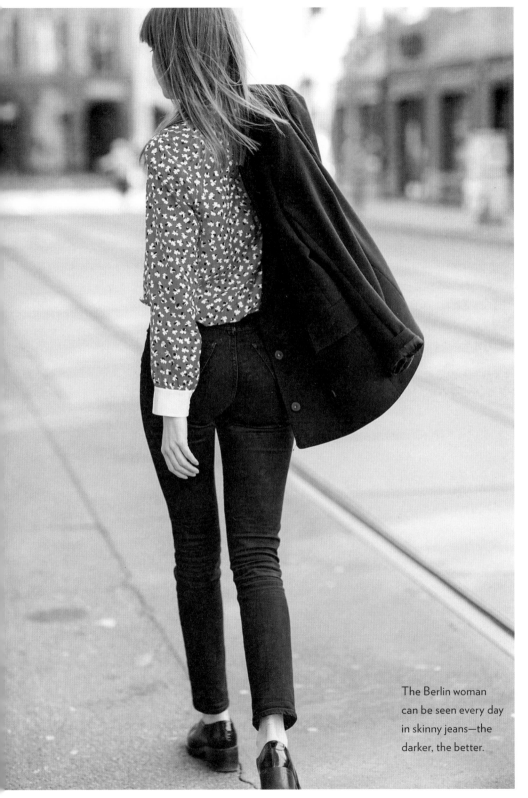

The Berlin woman can be seen every day in skinny jeans—the darker, the better.

# The Blazer

## The Berlin Look

A good blazer in combination with skinny jeans always works. In addition, the Berlin woman winds a big scarf around her neck as though she might have caught a nasty cold. Of course, she has not, but this allows the look to appear more laidback. Harem pants with wild prints also look good with an elegant black blazer. The main rule with the blazer: Just don't appear businesslike!

## THE RIGHT CHOICE

The right blazer falls down to the buttocks and is made of fine woolen cloth. In his time as creative director with Yves Saint Laurent, Tom Ford designed brilliant jackets. Stella McCartney is known for her razor-sharp Savile Row cut. I additionally recommend a short and not-so-straight variation from an avant-garde label like Comme des Garçons.

## How to Correctly Style the Blazer

The Berlin woman would rather go naked than wear a good white blouse under her blazer. She reaches for her favorite T-shirt (white, gray, or black) and for the inevitable skinny jeans. To break up the look, you can wear the sleeves pushed up and display a nice thick bracelet.

## Please Don't!

Wear a double-breasted style or matching pants. Vibrantly colored blazers in red, pink, or turquoise do not work at all in Berlin; the ideal color is gray or dark blue.

## The Upgrade

Striking fabric, a peplum hem (!), or a distinctive shoulder line. Suddenly, the blazer is perfect for a night out! Supercool: a smoking jacket with a shawl collar.

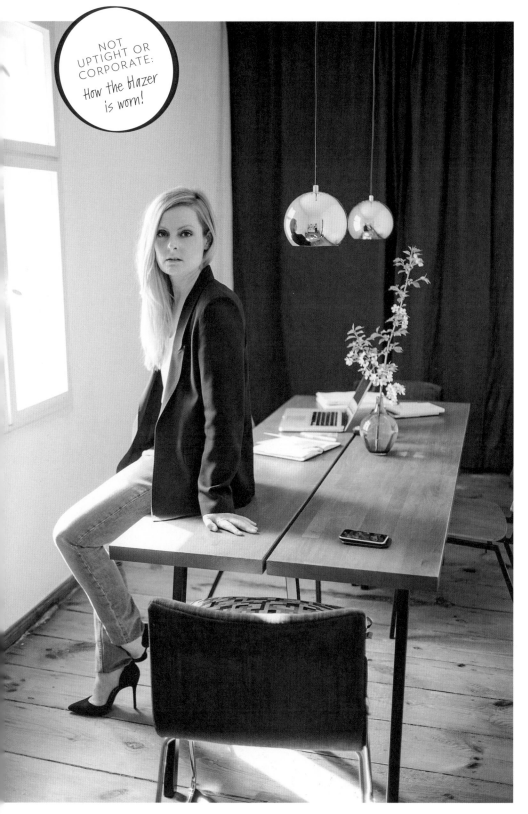

NOT UPTIGHT OR CORPORATE: How the blazer is worn!

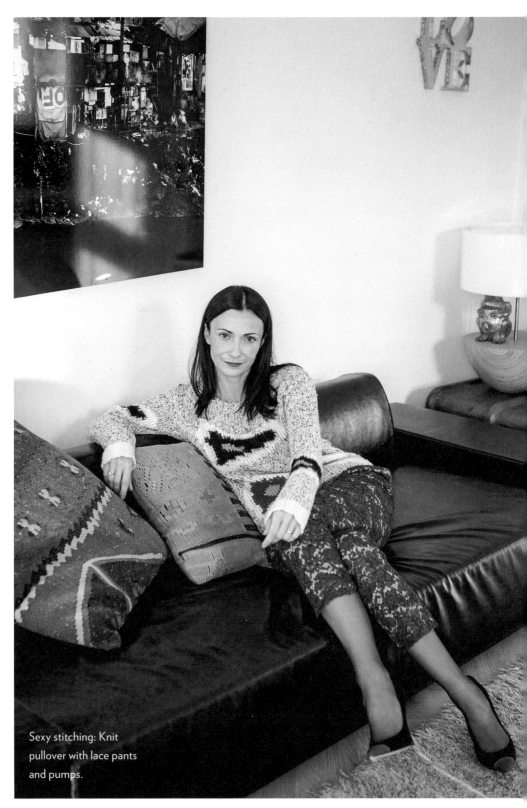

Sexy stitching: Knit
pullover with lace pants
and pumps.

# The Knit Pullover

## The Berlin Look

You can do no wrong with a black V-neck pullover. In the winter, one primarily wears coarsely knit boyfriend-style sweaters. The courageous will reach for one that looks hand knit. You can drape a pretty necklace around your neck so that the combination does not appear too homespun. Add chic pants of brocade or lace and tantalizing pumps to complete the Berlin look.

## How to Correctly Style the Knit Pullover

With a fine gold chain and a small pendant drawing the eye to the cleavage or the base of the throat, a pullover appears sophisticated and sexy. If a dinner party is on the agenda, one reaches for sparkly costume jewelry and an enameled leather handbag, arrives punctually at the host's front door, and, above all, looks very much relaxed.

## Please Don't!

Wear pullovers that are too narrow or are too short—those cut above the belly do not work at all. Nor do those with pastel tones and puffed sleeves. You should also never squeeze a blouse under a pullover—it's better to wear only an undershirt.

## The Upgrade

I gladly buy my cashmere pullovers through J.Crew's online shop. The quality is unbeatable for the price. Otherwise, I believe in the brands that traditionally specialize in cashmere, such as Malo or Iris von Arnim.

## THE RIGHT CHOICE

I buy my pullovers one size larger so that the length is right in the arms and the body (the lower back should always be kept warm in Berlin). My must-have colors are black, sweatshirt gray, and dark blue.

# The Leather Jacket

## The Berlin Look

The Berlin woman makes no compromises in the matter of a leather jacket: It must be in the biker style with a short and tapered cut and made of smooth black leather. Patina is no flaw—quite the contrary. The Berlin woman is proud of her leather jacket because it conveys the attitude of the wearer: nonconformist, sexy, tough. Nice styles are rare and, as a result, they sell like hotcakes—don't make the mistake, either in a shop or online, of sleeping on it for another night. If the jacket fits and is not more expensive than your rent, strike.

## How to Correctly Style the Leather Jacket

Rule Number 1: Whenever it is too warm for a light parka, the Berlin woman throws on her leather jacket. She also matches it with a summer dress or a little cocktail dress and even with a full-length evening gown. Rule Number 2: If the look is too chic with a blazer, simply dress down with a leather jacket.

## Please Don't!

Stay away from the '70s leather jackets found in typical Berlin second-hand stores! The fact that one does not combine a leather jacket with leather pants should be clear, unless you are the lead singer in a heavy metal band. Absolute no-go: leather jackets with snakeskin embossing.

## The Upgrade

A designer leather jacket, perhaps the minimalist biker model, Blister, by Rick Owens, or an interpretation of the biker jacket by Balenciaga or Céline. In winter, the Berlin woman will happily wear a variation lined with lambskin.

## THE RIGHT CHOICE

Definitely pay attention to the material: It must be the finest calf, kid, or lamb leather, somewhat matte rather than shiny. The cut must fit like a glove (particularly in the shoulders!). Also imperative: not too many trifles. Shoulder epaulets and an asymmetrical zipper are compulsory.

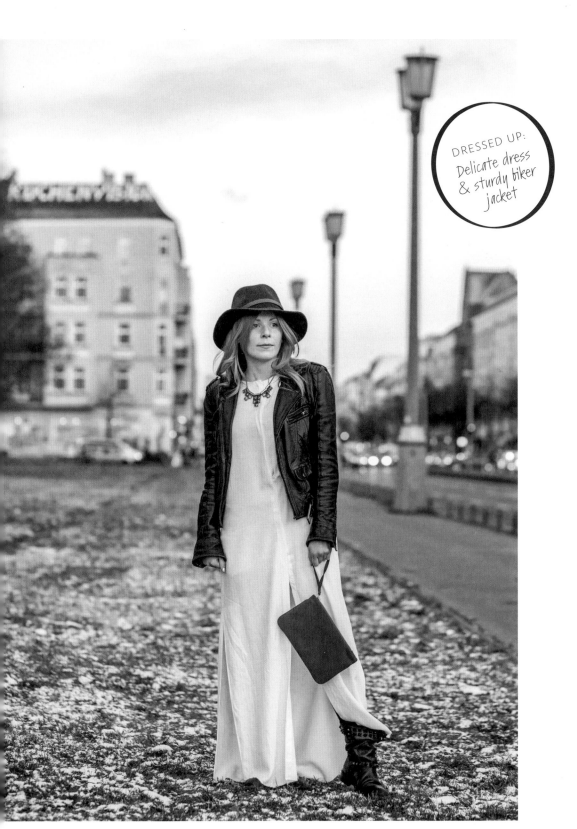

DRESSED UP:
Delicate dress
& sturdy biker
jacket

39

# The White Blouse

## The Berlin Look

One could say that the white blouse is also considered a basic piece in any other city. But, it really does stand for the new Berlin look. Here, however, we are not dealing with a good tapered office blouse. Rather, think of a casual, oversize, and billowy shirt that could have also come from a lover.

## How to Correctly Style the White Blouse

There are many variations, but in every case, the Berlin woman has a simple white shirt hanging in her closet. The cut is loose, and the blouse is primarily worn over jeans. Moreover, one should own a blouse without a collar for warm summer nights, ideally with romantic lace detailing or a few ruffles.

## Please Don't!

A tapered white blouse with stretch fabric is much too well behaved for Berlin. A white blouse is also never tucked into the pants or accented with a logo belt.

## The Upgrade

A fine silk blouse from Equipment, Kaviar Gauche, or Mongrels in Common. There is no better companion for Berlin evenings. Indeed, avoid the currywurst stand (p. 194)—the nasty sauce spots will never come out.

## THE RIGHT CHOICE

My favorite white blouse is a crumpled-looking one by Acne that I ball up after washing so that the effect is preserved.

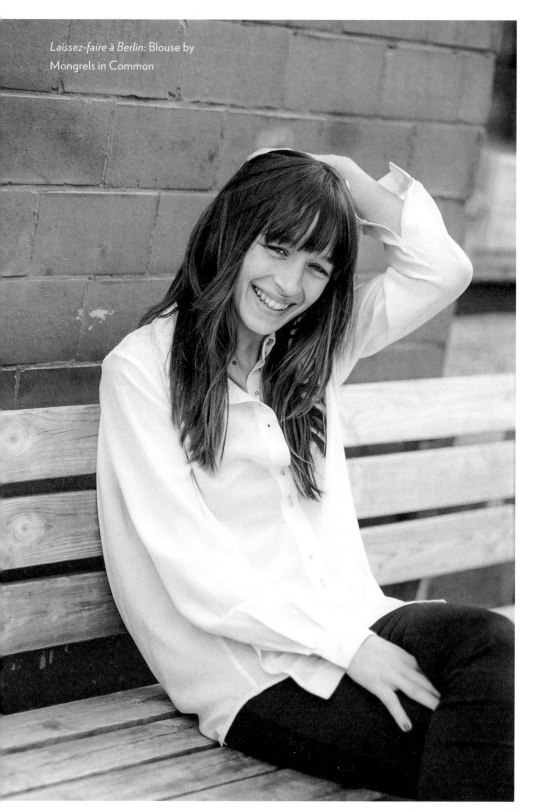

*Laissez-faire à Berlin*: Blouse by Mongrels in Common

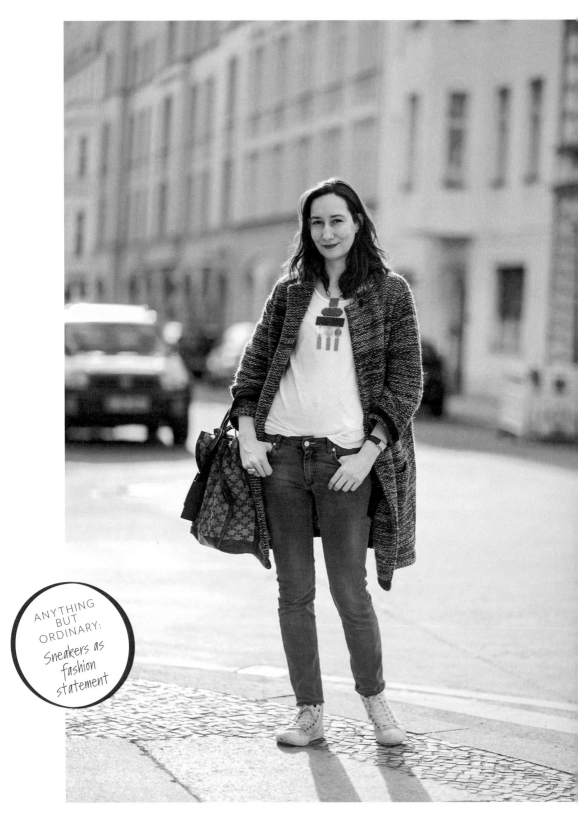

ANYTHING
BUT
ORDINARY:
*Sneakers as fashion statement*

# Sneakers

## The Berlin Look

Whether you like them or not, what western boots are to the cowboy, the sneaker is to the Berliner. Sneakers are not only an accessory, but part of the lifestyle. Certainly it is due to the fact that those in Berlin will gladly go by foot or bike whenever possible. Indeed, one should not mistake these shoes for contemptible, geeky athletic shoes. Sneakers are a fashion statement.

## How to Correctly Style Sneakers

The effect of sneakers should by no means be underestimated—they are like the dot above the *i* in Berlin. The Berlin woman prefers to wear them in strong colors with her otherwise simple look. In summer, sneakers work with shorts or a miniskirt—without hosiery, of course. And remember: The more bright the details, the better. The only exception: high-top Converse Chuck Taylors. They are worn in white, black, dark blue, or red.

## Please Don't!

Wear sneakers from known luxury brands or, worse still, those with a logo print and Velcro fasteners. Unlike the absolutely stylistically confident Helmut Newton, who always coated his white shoes with a White-Out-like shoe polish, don't be afraid of sneakers looking worn.

## The Upgrade

Design the sneakers yourself. In other words, put the colors and materials together from the sole up to the laces. Customizing programs such as Nike iD make this possible. Or you could splurge on a couple of smart pieces from Pierre Hardy, Rick Owens, or Martin Margiela.

## THE RIGHT CHOICE

Preferred brands are Nike, Adidas, and Converse. Moreover, the classics from Vans and New Balance have made a comeback.

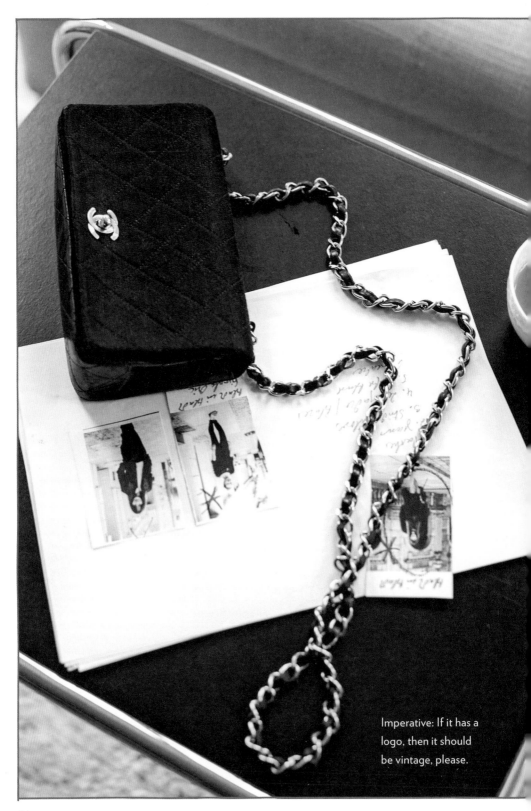

Imperative: If it has a
logo, then it should
be vintage, please.

# ACCESSORIES

The Berlin woman loves accessories. If you are thinking about
an overly expensive "It" bag, consider your purchase carefully,
because as with the basics, only select accessories are hip in the
capital. They must fit the lifestyle of the Berlin woman.
As always, the materials or *the story* behind them are important,
not the label. This guarantees that the items will continue to be
relevant over several seasons. A bold, yet chic choice in eyewear
is important for the stylistically confident Berlin woman, and
perfume must also not be missing from the list of absolutely
necessary items—provided that the scent really fits her personality.

Shoes 46 · Bags 50
Eyewear 54 · Jewelry 58
Hats and Scarves 62
Perfume 66

# Shoes

The Berlin woman is almost always in motion!
Her typically simple look is upgraded with the right shoes.

## DON'T FORGET

Shoes are the status symbol of the
Berlin woman; she varies her look
with them. I wear stiletto heels in
spite of cobblestones and regard-
less of whether they break or not.
She may be stylish, but the Berlin
woman is not always practical!

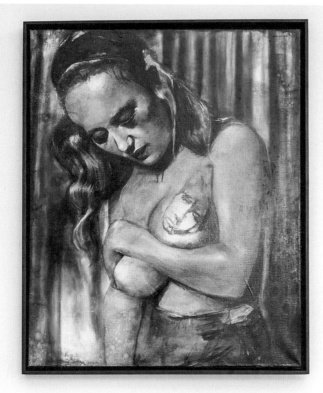

Which is the true masterpiece? Left, Martin Eders' *Old Tattoo*; below, Angelika's "best-of" black ankle boots.

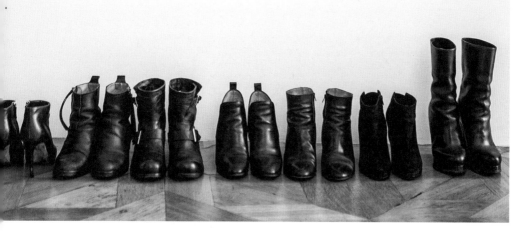

# *Walking in her shoes:*
# *The most important thing in a Berlin woman's closet!*

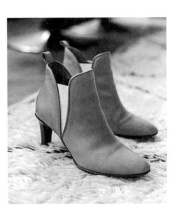

## 1. Ankle boots

The Berlin woman will happily invest a month's rent in designer ankle boots because she can upgrade her basic look with them. Important: The shoes should always be made of real leather and have a very robust, not-too-high heel. A practical zipper or an elastic band on the side? Perfect!

Chloé ankle boots

## 2. Wedge pumps

Those who wear pumps with a stiletto heel in Berlin may have to bring the shoes to the repair shop the next day. Wedge heels are a super alternative and are also more comfortable.

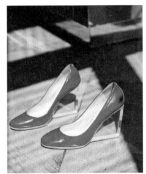

Martin Margiela wedge pumps

Repetto ballerina flats

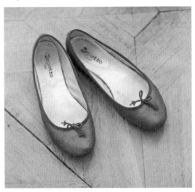

## 3. Red ballerina flats

Think of Dorothy from *The Wizard of Oz*—her red, glittering shoes have magic powers. This is also true for simple red ballerina flats. They are perfect for the summer and look enchanting with jeans and white summer dresses. The leather should be wonderfully soft so that no blistering occurs.

# 4. Statement heels

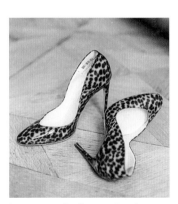

Leo pumps by Rupert Sanderson

A pair of fancy high heels in an animal print or metallic gold also belongs in the Berlin woman's closet. Leopard-print shoes look sexy with jeans and a white blouse or a simple gray sweater. Also imperative: Wear heels with bare feet; never put on skin-colored hosiery.

# 5. Pointy-toed pumps

Like the Parisian woman, the Berlin woman loves Isabel Marant. The designer is the queen of bohemian chic—above all, her shoes are key pieces. In addition to her boots and wedge sneakers, her bow pumps are considered legendary.

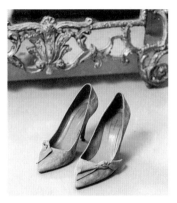

Bow pumps by Isabel Marant

# 6. Strappy heels

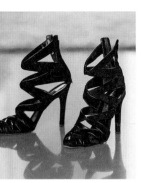

Heels by Vionnet

With their elaborate design, these shoes are a mixture of heeled sandals and pumps. The only disadvantage: These strappy shoes usually have staggeringly high heels. I have sworn to myself that I will never buy shoes with heels higher than three inches. Nevertheless, I am tempted to buy such models over and over again…

## MORE OPTIONS

Keds and espadrilles in the summer and, in winter, riding boots by Ludwig Reiter or snow boots by Sorel. Please only wear Ugg boots as house slippers.

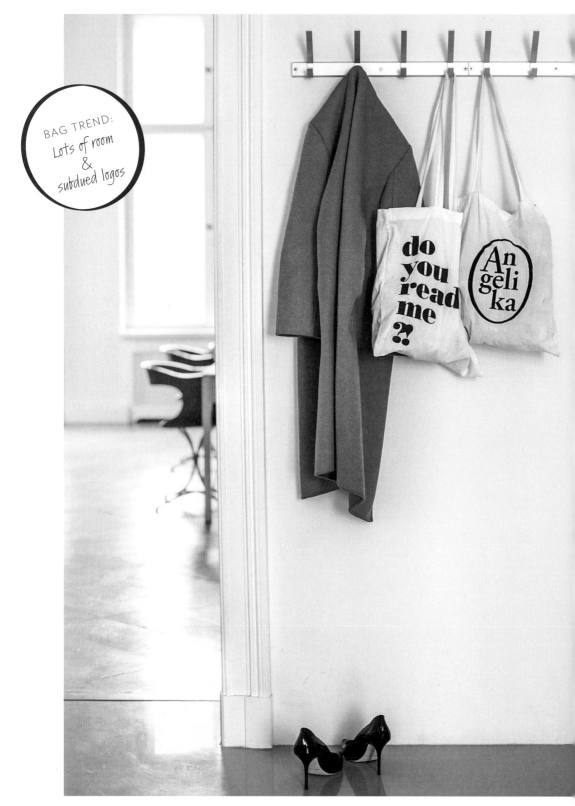

BAG TREND:
Lots of room
&
subdued logos

do you read me ??

An geli ka

50

# Bags

If there is a must-have in Berlin, it is a large bag. The Berlin woman generally lugs her mobile office around with her. First of all, a bag should offer enough room for daily necessities, from an iPad to a cosmetics bag. Large logos are considered unacceptable. The Berlin woman prefers to reach for a simple tote bag. In the evenings, she chooses a vintage model or discreet classics by well-known designers.

## DON'T FORGET

||||||||||||||||||||||||||||||||||||

Phony designer handbags or cheap imitation leather are always and forever an absolute no-go.

## *It's in the bag:*
## *Six handbags you must have!*

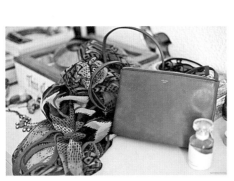

The "small gray" by Céline

# 1.Small shoulder bag

A small leather bag is a pretty and timeless companion. Favorites are those by Céline or a vintage Chanel. An important detail is a long strap, as the Berlin woman will happily go to a party on her bike.

# 2.Clutch

Such a small, elegant evening handbag stands for the new Berlin style—when you go out, it's a quiet little bit of *oh là là*. A clutch alters the posture—try it out!

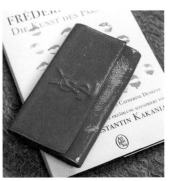

YSL red gloss clutch

Coccinelle/Kostas Murkudis clutch

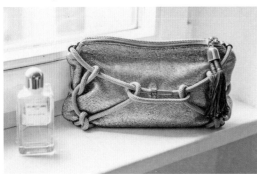

# 3.Artsy clutch

For the special occasion, an unusual design is a good conversation-starter. "What are these ropes on your bag?" "This is a design by Kostas Murkudis, have you heard of him?"

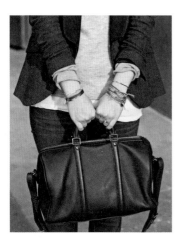

# 4. Everyday handbag

The search for Mr. Right is not half as important to the Berlin woman as the hunt for a perfect everyday handbag. She always needs her belongings with her, but the handbag must still look good. The Berlin woman will be floating in accessory seventh heaven if the bag also comes from a cool label.

Louis Vuitton SC bag

# 5. Shopper or tote bag

A shopper must be particularly large and sturdy. It is not only a matter of bringing groceries home, but also various drugstore products, loaves of bread, and that petite pair of sandals that just happened to be on sale. A laptop is stuck somewhere in between. The shopper by HACK is carried at one of my favorite boutiques for young labels: Wald (p. 86)!

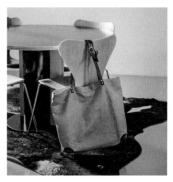

HACK shopper

Canvas tote bags

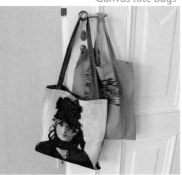

# 6. Canvas tote bag

The Berlin woman prefers to carry a giveaway tote bag over her shoulder rather than an ostentatious logo or imitation-leather fake handbag. In Berlin, it is good form to carry tote bags from culturally oriented events or shops. It's a way to show where you have been and what you like.

Glasses fetish: One not only diligently collects restaurant receipts in Berlin, but also accumulates glasses with which to read them!

# Eyewear

From thick-framed hipster glasses to big Hollywood-style sunglasses, in Berlin, the choices in eyewear are vast. There are special boutiques in which you can buy vintage models as well as current designer glasses. The Berlin woman displays a special daring with this accessory: She often opts for a thick horn-rimmed pair or a retro model à *la* Franz Beckenbauer.

## DON'T FORGET

If you don't have a good glasses cleaning cloth, buy a Bielefeld glasses cloth made of linen (available through Manufactum). Wash your pair of glasses with water and dish soap and dry with the cloth, and they will be grease-free!

*Eye Spy?!*
*The most attractive glasses*

# 1. Sunglasses

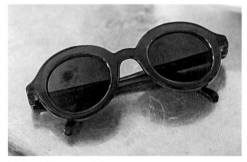

Mykita, Egon model

Mykita is a Berlin success story. The glasses are made of steel or acetate and are extremely light, but are surprisingly stable on account of their screw-free hinges. This is the shopper's only lament: "Egon, Ornella, Mafalda, Marlene… which should I buy???" Otherwise, choose discreet designer glasses without a gold logo on the frame.

# 2. Vintage glasses

The Lunettes-Selection boutique (p. 101) caters to the inter-city demand for vintage glasses by famous manufacturers. So much fun can be had while trying them on—the experience is like that in no other shop. I love the drawers with the frames by Porsche Carrera or the German Cazal brand with extravagant glasses by Cari Zalloni from the 1980s.

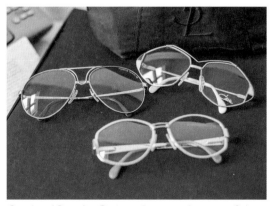

Cazal and Porsche Carrera glasses via Lunettes-Selection

# 3. Prescription glasses

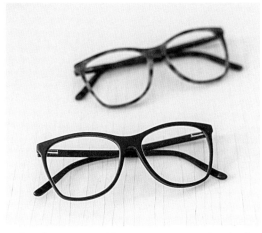

Owl Optics is a still-young label from Berlin that only distributes their glasses through their own online shop (owloptics.com) and can therefore offer them relatively inexpensively. However, your prescription from your eye exam must be on hand for the order. In lieu of the ubiquitous black, try glasses in beautiful midnight blue! One of my favorite styles is the Herbie model by Mykita (and keep in mind that sunglasses can be adapted to regular eyeglasses).

Owl Optics, model Drei in rosewood and midnight

# 4. Reading glasses

The Ray-Ban Caribbean and Wayfarer glasses are classics and work with (almost) every face—you can hardly go wrong with them. The frames in the "dark havana" tone are the loveliest. The color is not too harsh, so you can avoid the strict math teacher look.

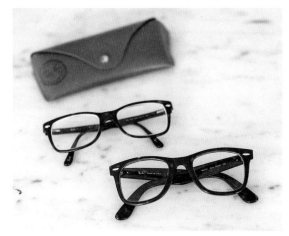

Ray-Ban, Wayfarer and RB5228 model

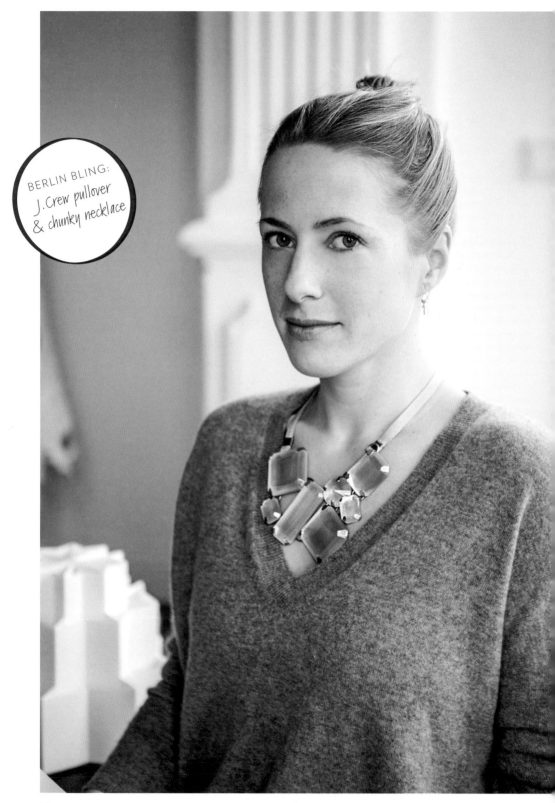

BERLIN BLING:
J.Crew pullover
& chunky necklace

# Jewelry

The Berlin woman does not need to buy her jewelry from the jeweler at the shopping mall. She relies on local jewelry designers, whose work is unique and eye-catching.

## DON'T FORGET

Coco Chanel knew long ago the effect of a single, thick gold bracelet. Do not buy sets of bracelets; rather focus on special pieces.

*Glitter and sparkle:*
*The adorned Berlin woman*

# 1. Rings

The Berlin woman is a loyal creature. She wears either a ring that she received as a gift from her man or best friend or one that is a valuable heirloom. The story also counts here: Where does the piece of jewelry come from and what meaning does it have?

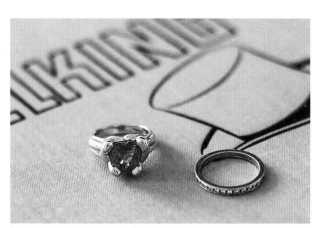

Rings by Otto Jakob and Cada

# 2. Friendship bracelets

Bracelets should not jingle on the arm too much; this irritates the Berlin woman when she is typing, whether she's working from home or at an office. This is why friendship bracelets made from fine small chains, cord, or leather are hip. The look seems to say, "I just got back from an exotic locale."

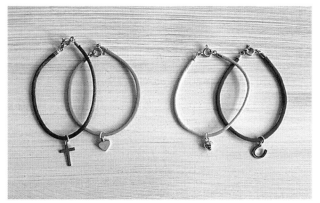

Bracelets by vonhey

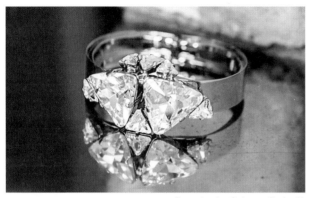

Bracelet by Sabrina Dehoff

**PSST:**
Have you heard of the "I need more rings" label? They make sensational rings from old silver and gold chains: rings.ineedmore.de.

# 3. Bracelets

A piece of jewelry by Sabrina Dehoff is a must for the Berlin woman. I have been a Dehoff fan since the very beginning and regularly pay a visit to her store on Torstrasse (p. 100). My weakness is her bracelets: I tend to go into a shopping frenzy every time I visit. My favorite piece is a thick Swarovski cuff.

# 4. Statement necklaces

The Berlin woman's look can be upgraded with a thrilling necklace in no time at all. There need not be an occasion for it. I wear statement necklaces throughout the day just the same as in the evening. A safe bet: Necklaces always look fantastic with a cashmere pullover or a simple T-shirt. I love my pendant by Cada. I am frequently asked what the "35" stands for (it is the Sanskrit symbol for Om).

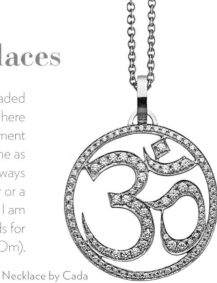

Necklace by Cada

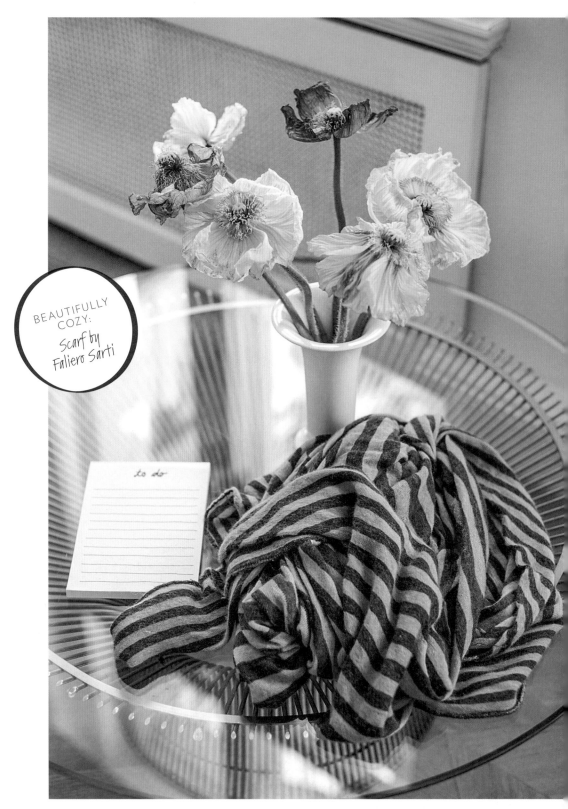

BEAUTIFULLY
COZY:
*Scarf by
Faliero Sarti*

to do

# Hats and Scarves

Wool caps and soft scarves: When it comes to wool accessories, the Berlin woman is drawn to the cuddly. It's no wonder that there is a huge number of Berlin designers who specialize in knitwear.

## DON'T FORGET

The Berlin woman is fond of neither conspicuous scarves from big brands (which are considered nouveau riche) nor prissy silk scarves. However, volume is very important. A scarf can never be too large.

*Come what* wool:
*The prettiest scarves and caps*

# 1. Patterned scarf
## by Lala Berlin

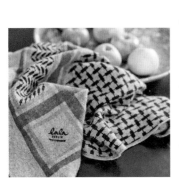

A cashmere, silk, or modal scarf by Lala belongs in every well-equipped Berlin closet, just as you would find jewelry by Sabrina Dehoff or a handbag by Kaviar Gauche. Her scarves are easy to care for and not at all scratchy (p. 91).

# 2. Knit scarf by Wolfen

I cannot get enough of Wolfen scarves (p. 93); I love the moss-stitch texture as well as the size. A scarf must be long enough for you to be able to wind it around your neck twice with the ends reaching over the shoulder. Anything else looks like a bandage!

# 3. Cashmere scarf
## by Faliero Sarti

This Florentine label, found in department stores, is my obsession. You will need to have a few bucks with you (the prices are really steep), but I swear that the purchase is worthwhile—the scarves are wonderfully light, warm, and have a certain something. I love my enormous cashmere scarf that is lightly felted and has open hemlines—this is exactly the kind of luxury that one allows oneself in Berlin.

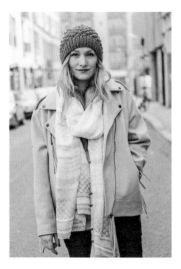

# 4. Wool cap

In winter, the Berlin woman will only venture out the door if she has a cap on her head. Important: It must sit in a tube-like, slouchy manner. It should be a little oversize so that there is enough remaining fabric to dangle from the back of the head. Many Berlin women buy their caps at COS because a virtually perfect style is available for purchase there every winter. COS (cosstores.com) is an offshoot of H&M located throughout Europe with three Berlin locations. An outpost of this reliable standby is due to open in the United States soon!

# 5. Fedoras

I am a hat person and have different fedoras by Mühlbauer and Hat Attack. It is simply fun to wear a hat, no matter if it's summer or winter.

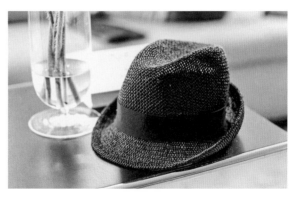

# 6. Fur hat

Hawkers offer various nostalgic East German souvenirs along the tourist paths; Soviet medals can be found alongside the Russian hats and headbands made of fur. The Berlin woman would never shop here, but *Uschankas* from other sources are definitely wearable. Don't opt for a sable variation, but rather keep an eye out for a vintage cap of red or arctic fox fur. Faux pas: caps with tails.

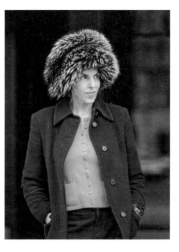

# Perfume

The Berlin woman places a great deal of value on her scent. Any old mass-produced fragrance from the duty-free shop is not an option. Moreover, perfume bottles are an important decorative element in the bathroom or on the dresser in the bedroom.

## 1. Escentric Molecules
### by Geza Schön

By the age of thirteen, he could already distinguish between more than a hundred scents. Today, Geza Schön is considered one of the most radical fragrance designers in the world. Each variety of Escentric Molecules contains only one single, highly concentrated fragrance. Kate Moss is a fan!

## 2. Eau Royal
### by Rancé

This classic perfume is from one of the oldest family businesses in the perfume industry, which has created beautiful scents since 1795. Rancé has other polished scents, such as Joséphine, Hélène, and Eugénie, if you do not like the original Eau Royal. The old-fashioned handmade soaps from Rancé are also marvelous.

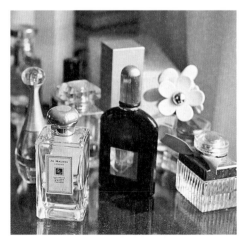

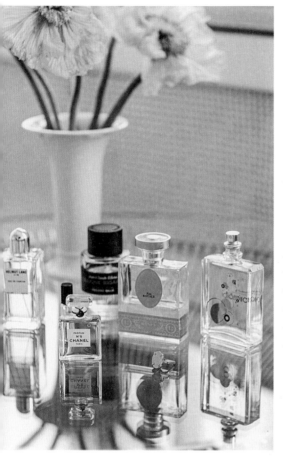

## 3. Dries van Noten
### par Frédéric Malle

Dries van Noten was developed with Frédéric Malle, the legendary French perfume producer, of whom I am a great fan. An oriental, exotic yet modern scent with notes of sandalwood, vanilla, bergamot… *mmm*! I wear En Passant in the summer and, in winter, L'Eau d'Hiver. On the Frédéric Malle website, under "Your Scent," you can fill out a questionnaire and then receive proposals on which scent would suit you. What a great idea!

## 4. Helmut Lang
### by Helmut Lang

A classic. The bottle always makes me nostalgic. Helmut Lang was a brilliant designer. Even though, unfortunately, he is no longer working in fashion, you can still treasure a bottle of perfume designed by him.

### DON'T FORGET

The Berlin woman prefers to not give fragrances as a gift. The nose is far too individual.

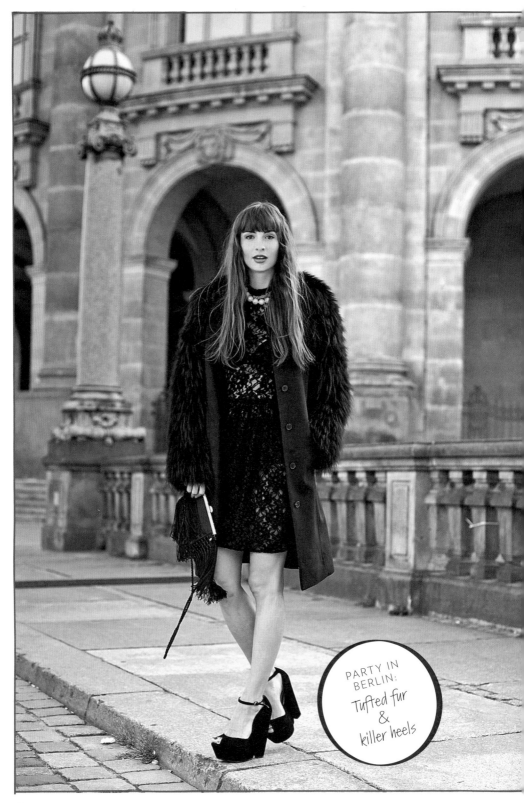

PARTY IN
BERLIN:
*Tufted fur
&
killer heels*

# BERLIN BY DAY AND NIGHT

In a city like Berlin, there is no strict dress code instructing us what to wear for each type of occasion. But, as everywhere else, women here have stood in front of the closet and despaired because they don't know what they should wear. It is incredibly easy to style an outfit. These are my tips!

Art Opening 70 · Dinner Date 70
The Theater 71 · Black Tie 71
Fashion Event 72
Yoga/Gym 72 · Country Outing 73
The Art of Traveling 74
Clever Shopping 76

# Art Opening

## *What's it all about?*

I am always pleased when I discover a new artist, but obviously such an evening does not revolve exclusively around the art. An art opening offers access to the grapevine. Old friends mention new projects and perhaps new projects can be undertaken together in the future. In any case, you'll have a coffee together very soon!

## *Dress code?*

An art opening is a classic after-work event. The Berlin woman has a pair of stylish shoes for such an event lying under her desk or, as I do, in the trunk of her car. A well-cut woolen blazer and a striped pullover paired with jeans will suit the occasion perfectly. Add a red scarf and a small shoulder bag—large handbags are out of place at such events since they are much too cumbersome. Just think of the crowd at the cocktail bar!

# Dinner Date

## *What's it all about?*

Someone great invites you out to dinner. You want to look sexy, but not tawdry.

## *Dress code?*

Choose a bright silk blouse, dark blue skinny jeans, sexy stiletto pumps by Louboutin, red polished nails, and slightly unkempt hair—you should by no means appear as though you have spent two hours in front of the mirror for this guy. I will also wear one sparkly bracelet with Swarovski glitter. However, the most important accessory is a thousand-watt smile.

# The Theater

## *What's it all about?*

A premiere celebrates a new stage production at the Volksbühne, at the Berliner Ensemble, or the Schaubühne. For those who have not yet been present for Simon Rattle and the Berlin Philharmonic Orchestra, this is a must! The contract with the British conductor will continue to run through 2018. Even if Berlin is the capital of street style, such an evening is an excellent occasion to take Berlin style to the next level with an elegant outfit.

## *Dress code?*

Yes, you can go to the theater in skinny jeans. The wash should be quite dark blue and the material should have no holes. I often wear my black smoking jacket by YSL and gold strappy heels with a unique clutch.

# Black Tie

## *What's it all about?*

An important media prize is being awarded, or the red carpet is being rolled out at the Berlinale, or you are attending an elegant wedding.

## *Dress code?*

If "black tie" is on the invitation, one wears a long evening gown, one that is very simple and without frills or glitter. If your name is Iris Berben, you may also come in a smoking jacket. Flat sandals look perfectly nonchalant in summer. Never wear hosiery and certainly not in flesh tones with a pearl sheen. If you do, you will immediately land on the worst-dressed list. I prefer to throw a black leather jacket over the dress rather than a fur jacket or stole.

# Fashion Event

## *What's it all about?*

A label opens a new shop or a designer, magazine, or PR agency throws a party during Fashion Week—invitations to such events are highly sought after. One must be a networking machine in the creative industry in order to land new jobs.

## *Dress code?*

You should step up your look, but not overshoot the goal. There's a fine line between well-dressed and well-intentioned. Not only the VIPs but also the bloggers and editors hope to be photographed—this raises their market value. It is not a matter of appearing in the right labels from head to toe, but that something "happens" in the photo. Your look must encapsulate a trend or, even better, create a style. Focus on one item of clothing or an accessory that emphasizes your virtues, such as long legs, long locks, or freckles.

# Yoga/Gym

## *What's it all about?*

You can practice yoga before work or during your lunch break—but the Berlin woman typically goes to her favorite class on Sunday morning or afternoon. The correct clothes are not only required on the mat, but also on the way to the studio.

## *Dress code?*

The Berlin woman would *never* leave the house in a velour tracksuit. The proven outfit, which is quick-off, quick-on in the changing room, is black, three-quarter leggings with a casual trench coat thrown on top. Shoes? The logical answer would be sneakers, but I go sockless with black kitten heels in good weather or snap on my Jimmy Choo biker boots.

# Country Outing

## *What's it all about?*

The Berlin woman loves to go away on the weekends. With luck, she has friends who invite her to their small cottage in the Uckermark or Prignitz, and she can find herself again just forty-five minutes away from Alexanderplatz and the bustle of the city center. The weekend look of the Berlin woman is rather rustic. There are always activities such as rowing games on the lake, forest walks, and berry picking. Not to mention the compulsory barbeque in the evening!

## *Dress code?*

You do not need to pack a lot in summer: jean shorts (they should be one size larger than necessary), a T-shirt, dark green Wellington boots, and a straw hat. For the evenings: a snug cardigan, boyfriend jeans, and bug spray. Instead of a designer overnight bag, the Berlin woman will happily use the big blue shopping bags from a well-known Swedish furniture store. You can crumple them so nicely in the back of the car!

# The Art of Traveling

Traveling well means packing light but nevertheless being well dressed for every occasion. My "less is more" mantra is also applicable to traveling. I have increasingly refined this practice over the decades. Naturally, it is much easier if one is not going to the polar circle, but I prefer to travel to areas where summer clothes can be worn year-round anyway—I have Siberia at home! I almost always travel with only carry-on luggage. Nothing drives me crazier than to waste unnecessary time at baggage claim upon arrival. While the other passengers are still waiting for their suitcases, I'll already be sitting in the bar of my hotel, enjoying a cup of tea.

# Checklist

**1.** Your in-flight outfit must be completely comfortable. Therefore, it is best to wear stretch jeans. Please do not fly in a tracksuit, not even if it's cashmere!

**2.** Wear a loose cashmere pullover with your jeans and make sure that it sufficiently covers your lower back and chest. Add another layer with a loose boyfriend blazer on top that you can combine with almost anything later.

**3.** I wear my ballerina flats with a supple elastic sole to the airport. A little bling in the form of rhinestones or a bow on the top of the shoe is permitted.

**4.** If possible, you should always have a large cashmere scarf in your baggage since it can be used for many purposes. It is particularly good for snuggling up, so your neck doesn't get too cold from the drafty plane.

**5.** Do you still remember the days of the beauty case? I always used to bring an entirely too large cosmetics bag with me, but these days, I only travel with a small zipper bag and cosmetics products in travel size: a tube of toothpaste, a toothbrush, and a rich face cream that I also use for my neck, lips, hands, and elbows.

**6.** It is important to take a roomy, but nevertheless manageable bag on board that will fit magazines, a laptop, and cosmetics—as well as a somewhat smaller handbag for when you are on the move at your destination.

**7.** And in the suitcase? Inside is a pair of high heels for special occasions, a shimmering silk top, a clutch, lingerie, and a nightgown by Celestine Lingerie.

# Clever Shopping

Even if online shopping is booming, there is still nothing better than the occasional successful foray into the best shops of the city. Berlin boasts a huge variety of shops and the Berlin woman has a handful of favorite addresses that she heads to regularly. Moreover, like every woman in the world, she loves to discover new labels. But which pieces have really landed in the closet and then proven themselves over and over, day in and day out? If you keep a few of these tips in mind, learned from shopping in Berlin's various shopping districts, not much can go wrong.

## A Few Rules to Shop By:

## 1. *Those who shop cheap pay twice.*

The Berlin woman saves up for a pair of designer boots rather than buying cheap shoes made of imitation leather every month that will only hurt her feet. For example, one can wear the Acne Pistol boots over several years, assuming you know a good shoemaker who will resole the comfortable shoes every four to six months.

PSST:
The best shoe repair shop in the city is Schuh Konzept at Bleibtreustrasse 24 in Charlottenburg!

# 2. *Don't miss sample sales.*

Almost as exciting as Christmas, designer sales are announced via e-mail or Facebook. The Berlin woman circles the day on her calendar in red and then bikes over during her lunch break.

# 3. *Keep tabs on what's new.*

So that the Berlin woman does not miss out on the best, she has a subscription to newsletters from her favorite online shops. For me, it is Net-a-porter, Mytheresa, Stylebop, and J.Crew. One doesn't always buy something—the newsletters are so good that it is simply a pleasure to look at the latest collections and combinations.

# 4. *Focus on the classics.*

These need not be pieces like the Hermès Birkin bag; that's a better fit for New York anyway. But the concept is right; after all, the bag is just as expensive as it is rare due to its excellent workmanship. The Berlin woman invests her money in well-made, timeless articles of clothing. And, yes, a curated selection of designer articles can be found in her closet.

# 5. *Resist rushed shopping.*

A quick look through H&M, Zara, or COS after work? Before you know it, you're standing in line at the cashier with a trendy, sexy animal-print blazer; a discounted acrylic sweater; and a see-through silk top. You can buy one good item for the same amount. Take note: The cost of three quick shopping trips for cheap clothing would equal the cost of a pair of great shoes. Above all, avoid frustration shopping!

# 6. *Find a sales associate that you trust.*

"Looking for anything in particular?" Clearly a salesclerk who waits for boutique clientele like a spider in her web, following her potential prey throughout the shop at every turn, eliminates any desire to buy. However, in owner-operated boutiques, you can enjoy personal advice directly from the boss. They know their clientele and will unerringly advise on the right pieces.

# 7. *Go shopping with a friend whose style you admire.*

It's not only more fun to shop with a friend—she will also give her honest opinion. For example, I am sought out as a color adviser; my friend Esther does not go shopping without me. Afterward, we allow ourselves a lovely piece of cake at Princess Cheesecake (p. 200). I love it.

# 8. *Go on a trend safari.*

When you are in hip neighborhoods, take note of what people are wearing. Bomber jackets? Camouflage? Milkmaid braids? Who would have thought that all of these things would come into fashion again! If you see a girl at a traffic light in Neukölln in orange corduroy, one thing is certain—it's coming back again.

Shopping buddies:
The advice of a stylish friend
is invaluable when you are
looking for something new.

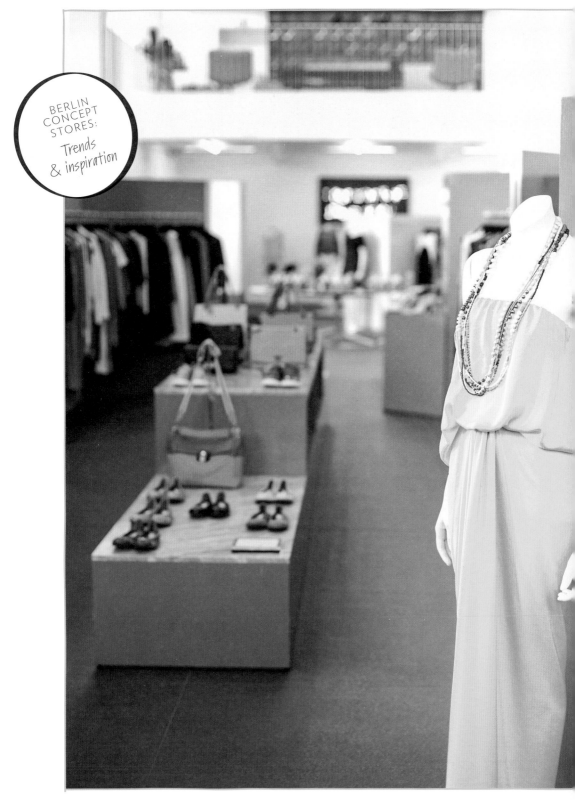

BERLIN
CONCEPT
STORES:
*Trends
& inspiration*

# A SHOPPING PARADISE

## The best addresses in Berlin for fashion, accessories, and more!

Berlin has something for everyone: There are world-renowned department stores and stylish concept stores, as well as many small designer boutiques. These are a few of my favorite addresses...

Concept Stores 82 · Berlin Labels 90
Specialty Stores 94
Green Fashion 96 · For Kids 97
Vintage 98 · Jewelry 100 · Eyewear 101
Lingerie 102 · Shoes 104
Chic Clicks 105
Online Shopping 107

# Concept Stores

## The Corner

**MITTE** Französische Strasse 40
U-Station: Französische Strasse
**CHARLOTTENBURG** Wielandstrasse 29
S-Station: Savignyplatz
**thecornerberlin.de**

### The Style

The owners, Josef Voelk and Emmanuel de Bayser, think internationally and see fashion in the context of Berlin. The two have their fingers on the pulse of all things hip and, as a result, it is a great pleasure to draw inspiration from their clothing, accessories, beauty products, magazines, and art. The selection has exactly the right dose of intelligent sex appeal and glamour.

### The Must-haves

Clothes by Carven or Alaïa, Céline handbags, Stella McCartney blazers, jewelry by Tom Binns, Lanvin ballerina flats, and Louboutin heels.

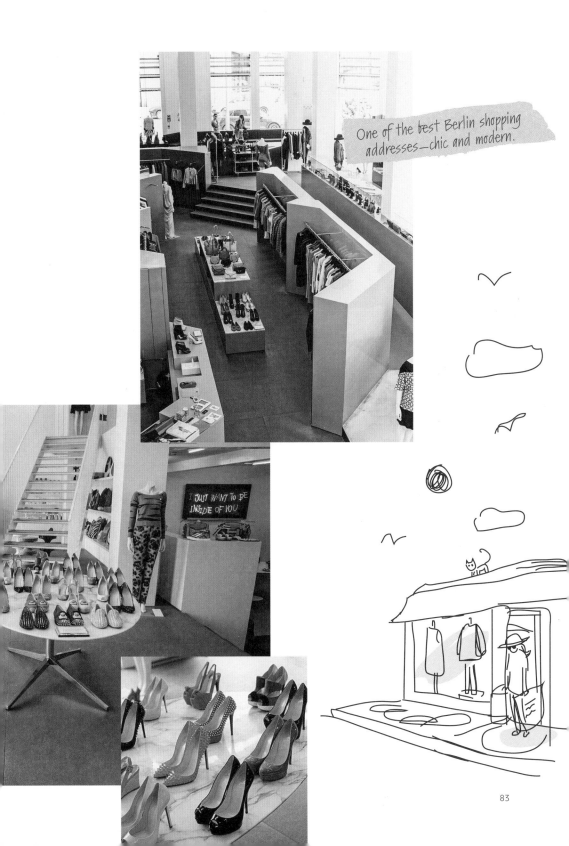

One of the best Berlin shopping addresses—chic and modern.

I JUST WANT TO BE INSIDE OF YOU

# Andreas Murkudis

**TIERGARTEN** Potsdamer Strasse 81e
U-Station: Kurfürstenstrasse
**andreasmurkudis.com**

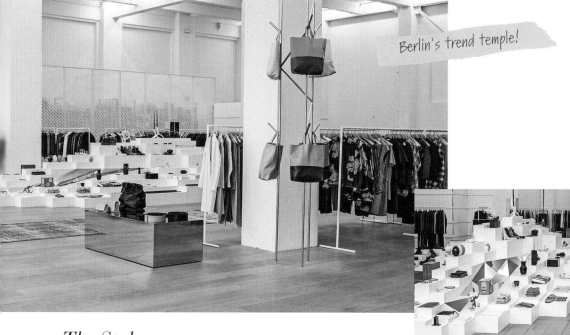

*Berlin's trend temple!*

## The Style

Andreas Murkudis has decisively characterized the style of Berlin in recent decades—one could also say that he invented it. Labels like Maison Martin Margiela, Kostas Murkudis, Céline, Jil Sander, Aspesi, and Johnstons of Elgin have the quality and logo-free unobtrusiveness that suits the city perfectly. The attitude of his shop is always forward thinking. The commercialization of the city center drove Murkudis to Potsdamer Strasse, where in 2011 he opened an enormous new shop designed by the Gonzalez Haase architectural duo, in which he sells not only clothes, but also select interior decor such as furniture pieces by E15 or porcelain by Nymphenburg.

## The Must-haves

Cashmere scarf and socks by Johnstons of Elgin in blue, gray, or black.

84

# Departmentstore Quartier 206

**MITTE** Friedrichstrasse 71
U-Station: Französische Strasse
**dsq206.com**

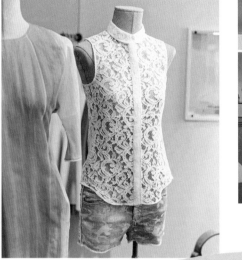

L–L–L–Luxury

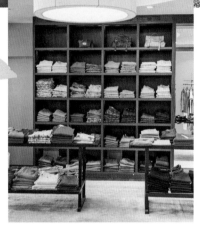

## The Style

The best labels and a pleasant
shopping atmosphere combine with
an excellent café that serves delightful
tea by Mariage Frères. There are select
products in the cosmetics department
(Erno Laszlo, By Terry, La Mer, Philip
B, Saint Barth) and fragrances such as
the perfumes by Frédéric Malle; try
and see which one suits you best. In the
small but very fine flower shop, there are
lovely bouquets and decorative articles.
In the juniors department, one can
find known labels such as A.L.C., Rika,
Isabel Marant, and jeans by JBrand or
Current/Elliott.

## The Must-haves

The black-and-white checked bags and
boxes themselves make for good deco-
ration on the home dresser. You can
buy just a little something: a calendar
by Graphic Image, wool and cashmere
shampoo by The Laundress, or hair
elastics by Blax.

# Wald

**MITTE** Alte Schönhauser Strasse 32c
U-Station: Weinmeisterstrasse
**wald-berlin.de**

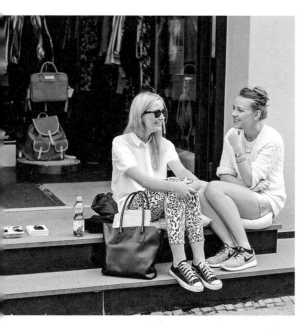

*From within the Wald!*

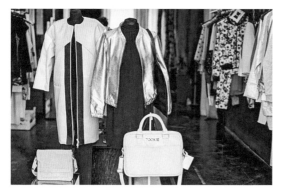

## The Style

The small indie boutique Wald by model Joyce Binnehose and stylist Dana Roski is one of the most interesting fashion addresses in the surrounding Hackeschen Markt. Here, the trend-conscious clientele will find young and hip labels such as One Teaspoon, Karlotta Wilde, Malaika Raiss, and many more. The makers are small style icons themselves—one would like to buy the clothes right off them.

## The Must-haves

White, gray, or black T-shirts and lingerie by A.O.cms.

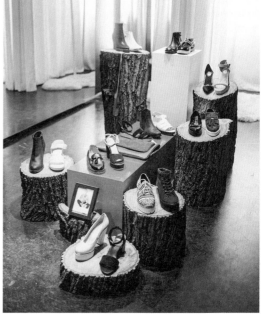

# Apartment am Alexanderplatz

**MITTE** Memhardtstrasse 8
U-Station: Luxemburg-Platz
**apartmentberlin.de**

## The Style

The upper floor is a gallery, entirely in white and bare except for a bouquet of lilies. Only insiders know where the spiral staircase leads: into a paradise for anyone whose favorite color is black. The style? "Glunge" ("grunge meets glamour"). Think of leather jackets or cashmere ponchos by Rick Owens and the best-of by upcoming, avant-garde designers, from Vladimir Karaleev to Sophia Kokosalaki or Moga E Mago. The sinister decor is created in part by the shop's own ceramics collection.

## The Must-haves

Sneakers by Rick Owens, Voodoo chain with crystal pendant, mini-sweatshirts by Cheap Monday Baby.

# Voo Store

**KREUZBERG** Oranienstrasse 24
U-Station: Kottbusser Tor
**vooberlin.com**

## The Style

In the Voo Store in Kreuzberg, enjoying the style of the store itself is part of the experience. The interior is big-city shabby chic and reminds me of New York's Lower East Side. With his choice of labels from Acne up to Wood Wood, Voo boss Herbert Hofmann manages a contemporary mixture of street style and high fashion. A highlight is the suede handbags by the Berlin newcomer label, Sloe. And in the event that you cannot find anything, the coffee here tastes especially good.

## The Must-haves

The pipe and skull notebook by Astier de Villatte, wooden platform shoes by Black/Wood.

# Schwarzhogerzeil I and II

**MITTE** Mulackstrasse 28 and 23
U-Station: Weinmeisterstrasse
**schwarzhogerzeil.de**

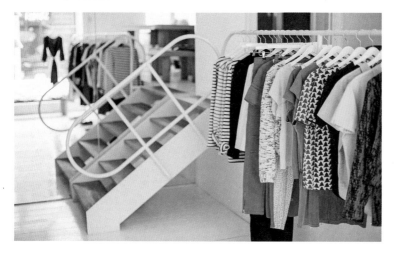

## The Style

Nicole Hogerzeil was one of the first store operators in Mulackstrasse, an idyllic lane with a small-town feeling, where today big-city fashion is on offer. She has complemented the androgynous Berlin style with feminine chic from Paris and was a very early seller of the Isabel Marant label. Other brands she carries include Eley Kishimoto and Zucca, jewelry by Sabrina Dehoff, and beauty products by "This Works"—a perfect mixture, in my opinion. Heike Makatsch also shops here! At Mulackstrasse 23, Schwarzhogerzeil II provides the smaller brands from larger labels, such as Isabel Marant's Étoile, Vanessa Bruno's Athé, and other young labels.

## The Must-have

The latest pair of boots by Isabel Marant.

# Acne

**MITTE** Münzstrasse 23
U-Station: Weinmeisterstrasse
shop.acnestudios.com

## The Style

The Swedish label embodies the look of the city like no other. The sales associates wear the Berlin street style magnificently. Pistol boots or the "Rita" leather jacket also characterize the Acne look. Next door, you can stock up on new T-shirts and sweatshirt hoodies by American Apparel.

## The Must-haves

Jeans, boots, leather jackets, and mohair pullovers.

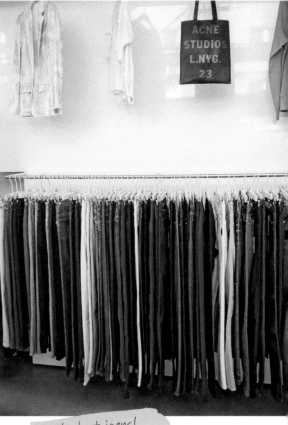

The best jeans!

# Berlin Labels

## Kaviar Gauche

**MITTE** Linienstrasse 44
U-Station: Luxemburg-Platz
**kaviargauche.com**

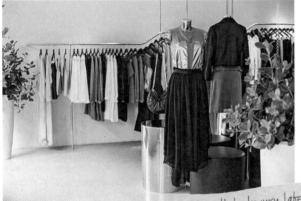

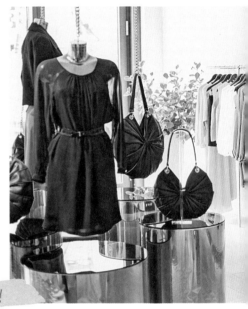

*Berlin's luxury label!*

## The Style

One of my childhood dreams was to fly through the meadows and woods like an elf or fairy. The Kaviar Gauche designers, Johanna Kühl and Alexandra Fischer Roehler, are able to evoke the look of a modern fairy with their designs. Frilly pink dresses do not work in Berlin, but you can combine a powder pink silk blouse with latex leather pants. The look of Kaviar Gauche is feminine, but never cute. Not without reason, the label is also known for its fantastic handbags, evening gowns, and wedding dresses.

## The Must-haves

The Lamella bag is a classic, but I love the Tornado clutch, either in black or nude. This little handbag looks incredibly chic and modern with jeans and a shimmery top as well as a long evening gown.

*Tip:* Kaviar Gauche Vintage is the mini-shop for pieces from previous seasons at sensational prices!
MITTE Brunnenstrasse 6
U-Station: Rosenthaler Platz

# Lala Berlin

**MITTE** Mulackstrasse 7
U-Station: Weinmeisterstrasse
**lalaberlin.com**

## *The Style*

Leyla Piedayesh, formerly of MTV, has definitely influenced Berlin style with her fashion. The native-born Iranian understands like no other how to transform rather conservative knit clothing, particularly if it is made of cashmere, into a contemporary look. The choice of her patterns—from tribal prints to eagles and ponies or neon geometrical shapes—is always unusual, but wearable. In her concept store, you can also find shoes, jewelry, and handbags by familiar labels such as Nina Peter, the wife of techno DJ Sven Väth.

## *The Must-haves*

A Middle Eastern–inspired scarf made of cashmere and a little sequined knit jacket for the summer.

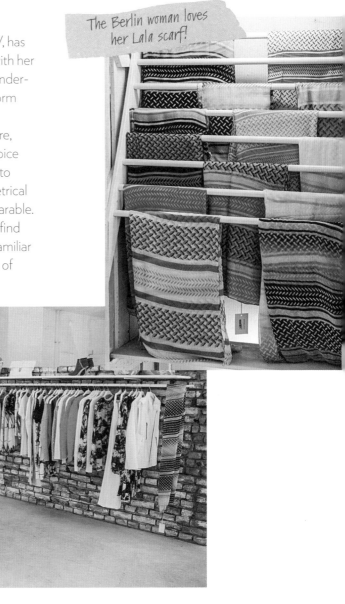

The Berlin woman loves her Lala scarf!

# Thone Negrón

**MITTE** Schröderstrasse 13
U-Station: Rosenthaler Platz
**thonenegron.com**

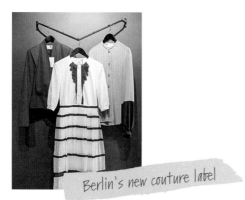

*Berlin's new couture label*

## The Style

With the opening of the Konk concept store (**MITTE** Kleine Hamburger Strasse 25), Ettina Berríos-Negrón has already written an important chapter in Berlin fashion history. The designer is also directing her own label that alludes to the old days when Berlin was a city of high fashion with many couture houses. Those who are in search of an extravagant evening gown or a top for going out must go into her salon on Schröderstrasse. The nostalgic, lavish interior with dark green paint and silk carpet is simply an inspiration.

## The Must-haves

Silk top, two-tone jacket in the uniform style, or a high-cut, full-length skirt.

# Mongrels in Common

**MITTE** Tieckstrasse 29
S-Station: Nordbahnhof
**mongrelsincommon.com**

## The Style

Livia Ximénez Carrillo and Christine Pluess's fashion has one detail in particular that inspires me: Rather than buttons made from mother-of-pearl or plastic, the blouses have small, gold stick screws that are reminiscent of piercings. I find piercings gruesome on a person, but they look sexy on a silk shirt.

## The Must-have

Silk blouse with pin fasteners.

*Clean chic with a certain something . . . very Berlin!*

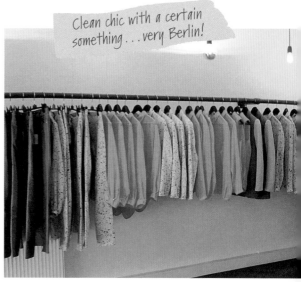

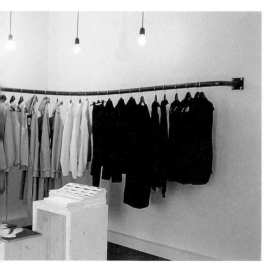

*I always find a new favorite sweater here.*

# Wolfen

**MITTE** Auguststrasse 41
U-Station: Rosenthaler Platz
**wolfengermany.com**

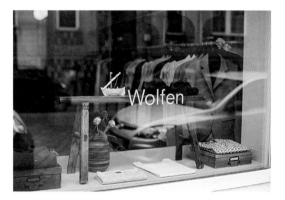

## The Style

Jaqueline Huste's hometown is Wolfen, a chemical-producing city in the Bitterfeld region of Germany. The architect founded the label by the same name in 2001 and today it is known for straight-edge knit designs. She recruited a retiree from Bitterfeld who produces the cardigans by hand in the classic moss-stitch pattern. The Wolfen shop lies at the beginning of Auguststrasse, Berlin's Kunstmeile (Art Mile)—in this neighborhood, the label has developed into a hot spot of the Berlin fashion scene.

## The Must-haves

Graphite gray round-neck pullover in a moss stitch, or a scarf.

# Specialty Stores

## International Wardrobe

**MITTE** Almstadtstrasse 50
U-Station: Luxemburg-Platz
internationalwardrobe.com

*Folklore can be so enchanting.*

## The Style

Katharina Koppenwallner travels around the entire world and buys traditional folk attire in China, Laos, Transylvania, Romania, and Poland, which she then brings back to Berlin. She has a flair for integrating the loveliest items from folk art into the everyday Berlin style. I wear a white folk blouse with red cross embroidery with jeans in summer and love the look of an embroidered pillow from the shop on my Eero Aarnio armchair.

## The Must-have

A hand-embroidered pillow from Kalotaszeg, a Hungarian region in the northwest of Transylvania.

# Chelsea Farmer's Club

**CHARLOTTENBURG** Schlüterstrasse 50
U-Station: Uhlandstrasse
**chelseafarmersclub.de**

## The Style

*My exclusive tip!*

British-infused fashion is available at CFC. The style is reminiscent of the conservative, landed-nobility look, but is much more casual due to owner Christoph Tophinke's well-conceived details. The jackets have a violet lining; there are wildly patterned knit socks as well as pants and pullovers in vibrant colors. For women, I recommend the tweed jackets; for men, there are great jackets and slim coats, as well as morning or smoking jackets.

## The Must-haves

Crocheted poppies to pin on, colorful socks, jodhpur boots.

# Purwin & Radczun

**TIERGARTEN** Tempelhofer Ufer 32
U-Station: Gleisdreieck
**purwin-radczun.com**

## The Style

In Berlin, pieces made to measure by appointment are rare. But there is a growing market for high-end places like this shop. The location is very Berlin: The salon is a not-yet-renovated house on the Tempelhofer Ufer. Why should you go? The selection of fabrics for suits, shirts, and blouses is one of the finest in the city—the owners themselves are counted among the best-dressed men in Berlin.

## The Must-have

A bespoke shirt or blouse.

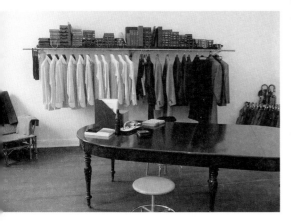

# Green Fashion

Fashion Week in Berlin for the Spring/Summer 2014 lines featured a green show room, because ecologically and socially sustaining fashion is in extreme demand. It is a contemporary luxury.

## Umasan

**MITTE** Linienstrasse 40
U-Station: Luxemburg-Platz
umasan-world.com

Each of the creators of this comprehensive vegan fashion destination are yoga junkies, like me. The style runs in the Rick Owens direction.

## Wertvoll

**PRENZLAUER BERG** Marienburger Strasse 39, U-Station: Senefelderplatz
wertvoll-berlin.com

The Berlin knitwear label caro e., silk clothing by the French label Les Raciness du Ciel, and leather handbags by Colette Vermeulen…a visit is always worthwhile.

## ARMEDANGELS

armedangels.de

Good basics, printed sweatshirts, and delightful summer clothes made from fair-trade cotton.

## TIP

A 100% vegan beauty brand made in Berlin is i+m Naturkosmetik Manufaktur— try the Energizing Splash Pomegranate Papaya.
iumn.de

# For Kids

## d.nik

**PRENZLAUER BERG** Wörther Strasse 14
U-Station: Eberswalder Strasse
dnik-berlin.de

Concept store for children with brilliant toys.

## Petite Boutique

**MITTE** Auguststrasse 58
U-Station: Rosenthaler Platz

Hip children's fashions with a French flair. Always sweet, never kitschy.

## Petit Bateau

**STEGLITZ** Schlossstrasse 27
U-Station: Sophie-Charlotte-Platz
petit-bateau.de

Still THE classic for baby onesies and striped shirts—also for mommy.

## Die wilden Schwäne

**PRENZLAUER BERG** Schönhauser Allee 63
U-Station: Schönhauser Allee
wildeschwaene.de

A creative toy store, and thus a very worthwhile address for children's birthdays and presents.

# Vintage

The Berlin woman loves vintage shops—but, these addresses are not to be mistaken for the kind of second-hand stores that smell like mothballs. In these stores, you can find fashion from the last or next-to-last seasons, as well as iconic designs of years past by internationally known labels.

## Soeur

**PRENZLAUER BERG** Marienburger Strasse 24, U-Station: Senefelderplatz
**soeur.tumblr.com**

An absolute shopping highlight— there are women who will stop by Soeur several times a week to carefully examine the latest pieces by A.P.C., Vanessa Bruno, and Acne, among others.

## Sommerladen

**MITTE** Linienstrasse 153
U-Station: Rosenthaler Platz

Gold mine deluxe—you could discover a top by Chanel or barely worn Prada shoes in the basement. No wonder: The area surrounding this second-hand boutique is one of Berlin's most refined areas.

## Pfeil and Piefke

**KREUZBERG** Böckhstrasse 46
U-Station: Schönleinstrasse
**pfeilundpiefke.de**

The fashion designers Therese and Ki, who were previously with the Berlin label Pulver, founded this small second-hand store in the trendy area, Kreuzberger Graefekiez.

## Garments Vintage

**MITTE** Linienstrasse 204-205
U-Station: Rosenthaler Platz
**garments-vintage.de**

A great mix of vintage and designer fashion: Those who sift through the racks will travel through fashion history and uncover true treasures.

## Das Neue Schwarz

**MITTE** Mulackstrasse 38
U-Station: Weinmeisterstrasse
**dasneueschwarz.de**

A good example of how professionally managed the so-called second-hand boutiques are these days. There are many top brands, beginning with Marni up to Wood Wood, but also Berlin designers, such as the avant-garde label Bless.

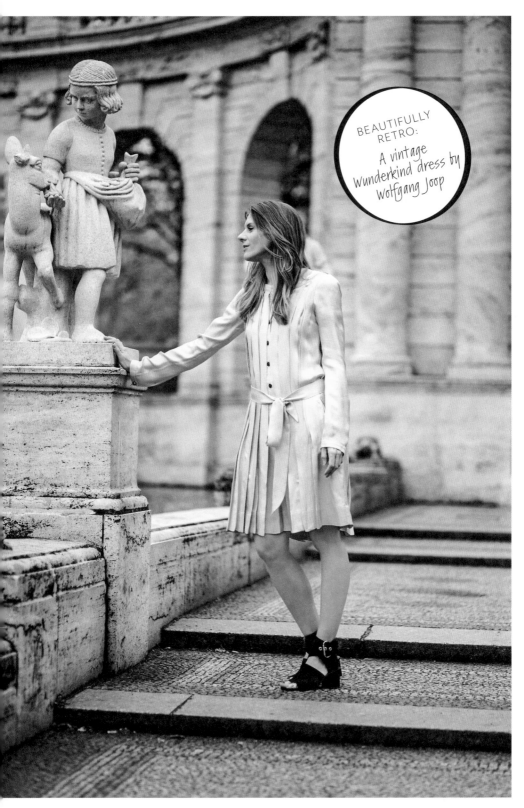

BEAUTIFULLY RETRO:

A vintage Wunderkind dress by Wolfgang Joop

# Jewelry

## Antique Jewelry

**MITTE** Linienstrasse 44
U-Station: Luxemburg-Platz
antique-jewelry.de

A large selection of antique and vintage jewelry. The antique valuables primarily date from 1750 to 1950. So pretty!

## vonhey

**MITTE** Brunnenstrasse 158
U-Station: Bernauer Strasse
vonhey.com

Friendship bracelets and Berlin designers such as Liebig, Hello Petersen, or James Castle. All of the cool kids shop here.

## Sabrina Dehoff

**MITTE** Torstrasse 175
U-Station: Rosenthaler Platz
sabrinadehoff.com

Anti-bourgeois bling. I have been a Dehoff fan from the very beginning and treat myself now and again with a new bracelet, delicate necklace, or pair of earrings.

## Jewelry Designers Online

* akkesoir.com
* inabeissner.com
* werkstatt-muenchen.com
* mari-couci.com

# Eyewear

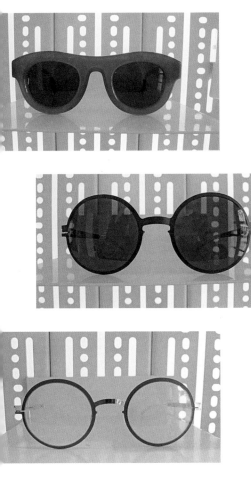

## Mykita

**MITTE** Rosa-Luxemburg-Strasse 6
U-Station: Alexanderplatz
**mykita.com**

The most successful Berlin eyewear
manufacturer. Even Hollywood
adores Mykita.

## Lunettes-Selection

**MITTE** Torstrasse 172
U-Station: Rosenthaler Platz
**PRENZLAUER BERG** Dunckerstrasse 18
S-Station: Prenzlauer Allee
**lunettes-selection.de**

Vintage glasses by Christian Dior,
Cazal, Carrera, Linda Evans, Persol,
and Ray-Ban.

## Specs Berlin

**MITTE** Alte Schönhauser Strasse 39
U-Station: Weinmeisterstrasse
**specs-berlin.de**

Designer glasses by Dita, Mykita,
Moscot, Persol, or Tom Ford.

# Lingerie

### Blush Dessous

**MITTE** Rosa-Luxemburg-Strasse 22
U-Station: Rosa-Luxemburg-Platz
**blush-berlin.com**

## The Style

Blush is my favorite lingerie company where you can find Eres, as well as Cosabella, Princesse Tam Tam, and the house brand undergarments. They also have a good selection of great-fitting bikinis. The interior is perfect—one feels as though she is in the boudoir of Marlene Dietrich.

## The Must-haves

Bandeau bikini by Eres, dressing gown by Blush.

Berlin's sexiest address!

# AM3 Schiesser Revival Store

**MITTE** Münzstrasse 23
U-Station: Weinmeisterstrasse

**am3store.com**

## The Style

German fine-ribbed cotton, newly imagined by designer Kosta Murkudis— wonderful undershirts, briefs, nightdresses, and pajamas. Also for men and children.

## The Must-haves

The "Charlotte" undershirt and the matching briefs, made from traditional double-rib cotton.

German classics, with a modern interpretation

# Shoes

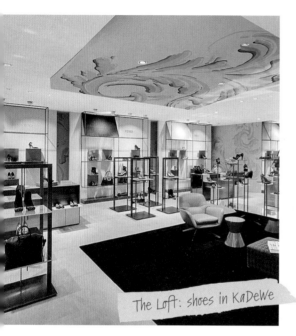

The Loft: shoes in KaDeWe

## KaDeWe

**CHARLOTTENBURG** Tauentzienstrasse 21-24
U-Station: Wittenbergplatz
**www.kadewe.de**

The Kaufhaus des Westens department store is one of the most significant tourist attractions in the city. The food and home decor departments count among my all-time favorites. An excursion into "The Loft" is particularly rewarding; it is one of the best shoe departments far and wide. I shop here for Jimmy Choo biker boots. I often take a detour on the first floor into the boutiques of Céline, Chanel, and Cartier. Just looking, of course. After the store closes, you can rummage around in the online shop. An old department store that has arrived in the twenty-first century—wonderful.

## Orlando

**MITTE** Rosenthaler Strasse 48
U-Station: Weinmeisterstrasse
**orlando-berlin.de**

The best shoe store in the city center, selling shoe labels such as Gold Goose, Pedro Garcia, and K. Jacques, along with clothing from labels such as Attic and Barn or The Hip Tee, jeans by Victoria Beckham, and cashmere scarves by Faliero Sarti. The advice of owner Stefanie Holuba is super and always honest.

## Le Coup

**MITTE** Steinstrasse 16
U-Station: Luxemburg-Platz
**lecoupshoes.com**

Fans of red-hot shoe trends are in bliss here. Minimarket, Jeffrey Campbell, Osborn, Surfaceto Air, Senso, and Lap à Porter are among the labels offered.

# Chic Clicks

The best fashion blogs, some in German and some in English.
No matter the language, the photographs will inspire!

## From Berlin

### * alexapeng.de

Coauthor Alexa von Heyden writes about fashion, design, beauty, and surfing with tongue in cheek. Simply about everything.

### * aloveisblind.com

Here, photographer Sandra Semburg publishes her best street style shots from Berlin, New York, Paris, and Milan.

### * journelles.de

The blogazine by the best-known fashion blogger in Germany, Jessica Weiss. Alongside fashion, it is about beauty and interiors. A must-see!

### * lesmads.de

Founded by Jessica Weiss and Julia Knolle; nowadays, Katja Schweitzberger is running the show.

### * primerandlacquer.com

Beauty blog by makeup artist, editor, and beauty writer Ariane Stippa, who is a beauty herself with radiant blue eyes.

### * ohfrantastic.com

Blogger Franziska has good style, a clean, straight-forward look that's not too girly. She is the epitome of the best of Berlin street style.

### * stilinberlin.com

Alongside Jessica Weiss, Mary Scherpe is one of the most important German bloggers and photographers. The blog also does a great job covering good food.

### * spruced.us

When Marc Jacobs or Stella McCartney come to the city, who are they guaranteed to meet? Marlene Sørensen! The half-Dane is a fashion journalist, photographer, and blogger with a sixth sense for style and witticism. Her blog appears in German and English—there are very few blogs at such a high level.

# International Sources of Inspiration

## * anywho.dk

Three attractive Danes introduce trends and present their best looks. Because Berlin street style is very heavily influenced by Scandinavian labels, this blog is a must-read!

## * carolinesmode.com

She has a great sense about what will become the fashions of tomorrow for Stockholm street style. In addition, Caroline Blomst herself is an important trendsetter.

## * thecoveteur.com

Prominent and central figures—Kelly Osbourne, Margherita Missoni, the Clarins heiresses—in the fashion world open their closets and present their greatest treasures.

## * garancedore.fr

Illustrator and photographer Garance Doré takes photos of and interviews the most important people in the fashion industry. A popular woman—everyone loves Garance!

## * thewall.elin-kling.com

The Swede Elin Kling is one of the most important fashion bloggers in the world. The most important lesson: Combine great basics with *oh lá lá* accessories.

## * joujouvilleroy.com

Eleonora Carisi counts among the new generation of international style icons. The brunette Italian with the Cindy Crawford birthmark near her mouth operates the YouYouShop in Turin and consequently has access to all of the newest and best fashion trends.

## * manrepeller.com

The promising New York journalist Leandra Medine has conquered the world of fashion with her slanted styling and witty text. Rightly very successful.

## * thesartorialist.com

Even if he has a lot of competition these days, Scott Schuman is still the most high-powered street style photographer overall, and he is particularly good when it comes to men's fashion.

## * the-northernlight.com

The Norwegian blogger Hedvig Opshaug stands for clean chic at its best.

## * advancedstyle. blogspot.de

This British blog provides the evidence: After the age of fifty, you don't have to settle for functional clothes and trekking sandals.

### More blog love

jakandjil.com
streetfsn.blogspot.de
streetpeeper.com
thelocals.dk

# Best of
# Online Shopping

## Top Eight

1. dsq206.com
2. mytheresa.com
3. net-a-porter.com
4. stylebop.com
5. thecornerberlin.de
6. farfetch.com
7. modaoperandi.com
8. jcrew.com

## Berlin Labels

addeertz.com

dont-shoot-the-messengers.com

cneeon.com

isabelldehillerin.com

kiliankerner.de

maiami.de

malaikaraiss.com

vladimirkaraleev.com

achtland.net

augustin-teboul.com

blaenk.net

blame-fashion.com

dawid-tomaszewski.com

frank-leder.com

hien-le.com

liebig-berlin.com

michaelsontag.com

perretschaad.com

emeza.de

apropos-store.com

## In search of...

A certain trend or item? On polyvore.com, you can scan the offers from the most important online shops at a glance!

# Naturally
## BEAUTIFUL

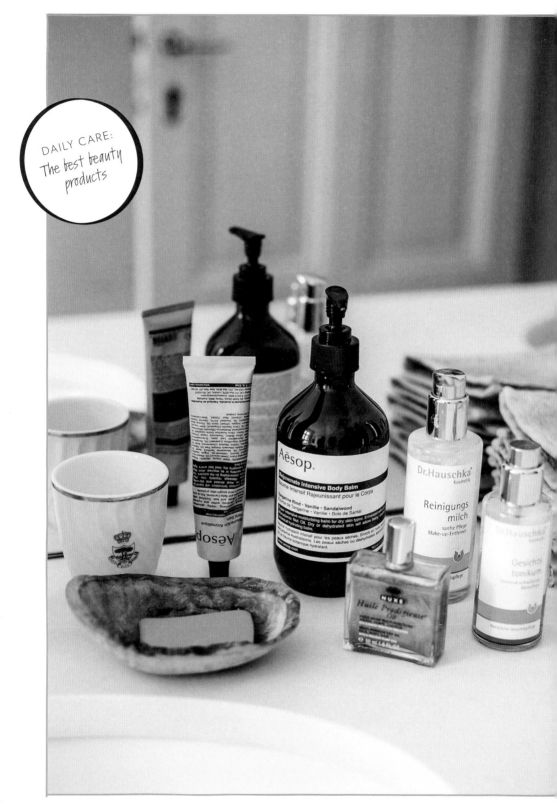

DAILY CARE:
*The best beauty products*

# THE BEAUTIFUL BERLIN WOMAN

For the Berlin woman, cosmetics must be effective and above all, contain many active natural ingredients. It is about products that optimally nourish and protect the skin. It is likewise important to the Berlin woman that she treats herself. She loves a pedicure with trendy polish just as much as wellness massages and detox smoothies. And natural scents—they function like an accessory and can be used to emphasize her personality and style.

Daily Beauty Routine 112 · Beauty Favorites 114
Beauty Faux Pas That Add Years 118
Beauty Stores 122 · Hairdressers 128 · Massages 129
Perfume Shops 130
Yoga in Berlin 132 · Yoga Gear 134

# Daily Beauty Routine

Time is of the essence in the morning, so each task must be handled efficiently. In each case, looking natural is always of the utmost importance.

1. Begin the day with *green tea*! The health advantages have been proven many times over.

2. For the Heike Makatsch look, do not wash your hair for two to three days and try a *dry shampoo* instead. This is not only quicker, but also makes the hair more manageable. The Berlin woman prefers to allow her hair to air dry for a natural look.

3. Use a really good *moisturizing cream* and not only on the face, but also the neck and the area behind the ears—I learned this from my mother. Use a day cream with a light SPF.

4. Instead of foundation, use a *tinted moisturizer.* Foundation looks painted on during the day. The current trend is the BB (Blemish Balm) and CC (Color Correcting) creams that should

spirit away every flaw. Both provide sun protection, hydration, and treatment benefits in a single cream (CC cream has more pigment than BB). Coauthor Alexa uses the original Blemish Balm by Dr. Schrammek for the nose and chin area.

5. *Water-resistant mascara* for the upper eyelashes is a must. To me, a bluish-black looks best, while brown mascara also appears very natural.

6. Instead of powders, de-grease the nose and forehead only with *oil-blotting paper.* This is available from retailers such as Art Deco, Bobbi Brown, or Shiseido.

7. A touch of *blush* on the cheeks conjures a freshness in the face. Orgasm by NARS looks great; the name alone brings a blush!

8. Dab on *lip balm* instead of lipstick. My favorites: Carmex balm, a touch of Eight Hour Cream by Elizabeth Arden, or Superbalm Moisturizing Gloss by Clinique.

9. Dot *brow gel* in your eyebrows and brush them into shape—this immediately lends more definition and expression to your face!

10. Give the fingernails a break from polish now and again and just massage in *nail cream* and then a good hand cream.

11. *Foot creams*, like those from Weleda with extracts of myrrh and marigold, nourish the skin and inhibit the formation of hardened skin.

12. Only use a *light perfume* and always apply sparingly.

13. To finish, a drop of Peppymint by Aveda for *fresh breath*—this is by far more elegant than chomping on chewing gum.

# Beauty Favorites

**1.** *Face:* The clear Regenerating Serum by Dr. Hauschka is the best cosmetic product that I know. It not only reduces small wrinkles, but it also strengthens the skin functions. I believe that the skin has its own powers and regenerates itself throughout the night. You must stay the course for a while; the change takes a few weeks, but it's worth it.

**2.** *Eyes:* When it comes to eye care, the products can be a little expensive. I have had good experience with the eye creams by La Mer and La Prairie. A little pot lasts forever (but costs a fortune—still, it is worth it!). Dab a small amount of cream under and over the eye and then smooth in with the ring finger—this won't apply as much pressure.

**3.** *Body:* I tend to have dry skin, so I need very rich products. In winter, I will happily use the Moor Lavender Body Oil by Dr. Hauschka. Likewise, the Rejuvenate Intensive Body Balm by Aesop works especially well. In summer, I switch to slightly lighter lotions, such as the Mallow Body Milk by Weleda or the Geranium Leaf Body Balm by Aesop (I love the scent!).

## 4. *Sub-zero temperatures:* If I have to go outdoors

in sub-zero temperatures, I use Skinfood by Weleda for my hands and face—it's an ultra-rich, deeply hydrating cream that smells very good and entirely protects the skin against the cold.

## 5. *Hands:* I have tried every hand cream known to

man and have repeatedly come back to this comparatively inexpensive product: a hand cream with organic almond oil, shea butter, and Coenzyme Q10 by Lavera Naturkosmetik (available at German drugstores and online!).

## 6. *For the feet:* The Weleda foot balm smells

slightly of lemon and is absorbed mind-bogglingly fast. You can immediately run around barefoot without leaving greasy footprints. Very nice after yoga sessions!

## 7. *Soap:* I am an old-school soap fetishist and abhor the

newfangled liquid soaps, as they stick to the skin. I prefer to use the Aleppo soap products with laurel oil or the organic soaps from the Provençal soap manufacturer Savon du Midi. My favorite is Garrigue—an unusual mixture of scents that is actually intended for men, but I love this scent on myself! And in May, I always opt for glycerin soap with a lily of the valley scent.

**8.** *Dental care:* I find dental care even more important than facial care! A lovely smile is the most important beauty factor. Even when it comes to dental cleaning, the Berlin woman pays attention to the "correct" product. I'd prefer for it to be organic, but it must work. One of my most important discoveries was finding interdental brushes that are meant to be used before dental floss. Since I started using them every night, I thankfully haven't had any more problems with my gums or teeth.

**9.** *Hair:* For my (quite fine) hair, I use the African Shea Butter Shampoo by Philip B or the inexpensive Elvital shampoos by L'Oréal. Also, Moroccan oil care treatments with argan oil are great. If I am blow-drying, I distribute a drop of the light version through the ends of my hair. Then my hair does not fly around in the winter or look as though I'm just returning from a beach visit in the summer.

**10.** *Nails:* For the nails, especially in winter, I use either the Apricot Cream by Dior or Neem Nail Oil by Dr. Hauschka.

**11.** *Lips:* To protect against dry lips caused by indoor heating, I use Dior Rose Cream in its pretty little white pot or the inexpensive Carmex, a drugstore product that every makeup artist in the world has in her case.

**12.** *Eyelashes:* An absolute must for me is the eyelash curler by Shu Uemura. If you curl your eyelashes upward with it, it opens the eyes and you will immediately appear more awake.

**13.** *Foundation:* Actually, I do not use a base makeup at all—at most, I'll use a lightly tinted moisturizer. I will gladly try those little samples that come in magazines and then sometimes buy a bottle of the latest magic cure.

**14.** *On the eyes:* I use muted shades: a gray or tan eye shadow. But, the fingernails and toenails can be colorful.

# 10 + 1
## RULES

# Beauty Faux Pas
# That Add Years

# 1. Heidi braids

Even if you believe that they make you look
younger, more than anything they just look silly.
Better to go with the classic ponytail.

# 2. Hair extensions

It doesn't matter if you use real hair or artificial hair—extensions generally
look conspicuous, particularly if several different tones are used. It's better to
choose a shorter haircut than to fake a mane that one didn't get from nature.

# 3. Fake tan

Tanning beds accelerate the skin's aging and artificial browning also
makes one appear old—particularly the yellowish-brown shade that
comes from a light bulb, not the sun. The Berlin woman is proud of her
paleness. Tanning-bed brown from the "Coin Caribbean" is a no-go.

# 4. Multicolored hair

Within the urban sprawl of Berlin, people have been known to dye their hair
many different colors—for example, a short, blond hairstyle with red-and-
black checkered bangs or turquoise-colored ends. Of course, the piercings
and manicure are color-coordinated. This is NOT the true Berlin style!

# 5. Glitter

Even if it is New Year's Eve, a crazy party arises, or glitter makeup appears on the catwalks of Paris, do not allow yourself to get carried away with either glitter eye shadow or lipstick and never mind the body glitter. And no, a mini rhinestone between the teeth is also not OK.

# 6. French manicure

The Berlin woman loves naturalness and this holds true for the fingernails. While a bright colored polish is fun on occasion, a French manicure and gel or acrylic nails are too gauche. Far more elegant: Instead of polish, "buff" the nails. Additionally, shine up the nails with special files for a bright luster.

# 7. The wrong makeup color

…and too much of it! Consult with an expert in the matter of makeup, for example, with MAC Cosmetics.

# 8. Dark or loud lipstick

Bright red lipstick looks fantastic up to age thirty. Then the look appears too hard—you can automatically look ten years older with this war paint! It's best to only use lip balm and dedicate your attention to making the skin look flawless.

# 9. Permanent makeup

Tattooed eyebrows, eyeliner, or lip liner always appear unnatural—for me, this is an absolute beauty taboo.

# 10. Perfume cloud

A heavy perfume cloud is a faux pas. With increasing age, some ladies seem to spray on an extra burst, particularly with quite heavy, musky notes. Always apply fragrances very sparingly, so that they are only noticed when people embrace or kiss you.

# +1. Homemade henna hair tinting

Gray vs. red: Many women attempt to camouflage their graying hair with henna. Red is better than black, but don't risk the frequently hideous result of bathroom-mixed henna tinting.

MY TIP:
A color appointment at Beate Kahlcke
(MITTE Luisenstrasse 14)!

# The Best
# Beauty Stores

## JACKS Beauty Department

**PRENZLAUER BERG** Sredzkistrasse 54
U-Station: Eberswalder Strasse

jacks-beautydepartment.com

The well-known makeup artist Miriam Jacks sells makeup and brushes in her shop from brands that she trusts, such as Butter London, O.P.I., Korres, and Tokyo Milk, among others. You can be styled by her for important events.

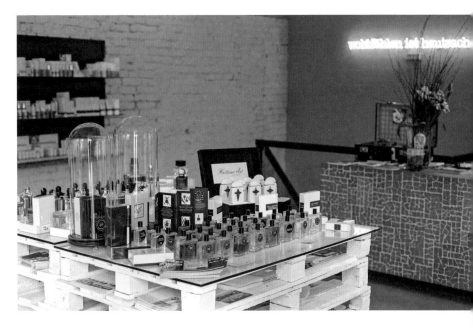

# Wheadon

**MITTE** Steinstrasse 17
U-Station: Weinmeisterstrasse
**wheadon.de**

This beauty concept store offers
various treatments and products,
such as natural makeup by Börlind,
Dr. Hauschka, and Susanne Kaufmann;
vegan cosmetics by Intelligent Nutrients
and Dr. Bronner; the fragrance creations
of Humiecki and Graef; and lovely gifts
such as candles by Parks.

## *The best treatment:*
The Post Berghain Treat, an oxygen
treatment that activates the cell
metabolism.

# breathe fresh cosmetics

**MITTE** Rosa-Luxemburg-Strasse 28
U-Station: Rosa-Luxemburg-Platz

**breathe-cosmetics.com**

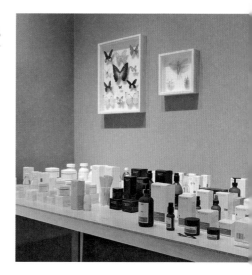

This shop offers an uncompromising focus on natural cosmetics, without chemical additives, dyes, or preservatives; special fragrance creations by Geza Beautiful or Sissel Tolaas; and excellent personal consultation from the owner, Gregor Vidzer.

# MDC Cosmetics

**PRENZLAUER BERG** Knaackstrasse 26
U-Station: Senefelderplatz

**mdc-cosmetic.com**

In one of the most wonderful beauty shops I know, Melanie Dal Canton sells one of my absolute favorite brands, Aesop, as well as Dr. Perricone and Santa Maria Novella.

## The best treatment:

Those who would like to do something special for themselves should book a stardust facial.

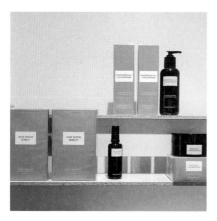

## Cowshed Soho House Berlin

**MITTE** Torstrasse 1
U-Station: Rosa-Luxemburg-Platz
**sohohouseberlin.com/cowshed**

The pedicure here with nail polishes by Essie is particularly popular. While you wait, you can sit comfortably in a big white armchair and browse through the latest gossip magazines.

## Schöne Mitte

**MITTE** Schröderstrasse 10
U-Station: Rosenthaler Platz
**schoene-mitte.de**

For those who wish for a younger, fresher, and more evenly balanced complexion, this is the right address for special beauty treatments that appeal to the body and soul.

## Tricia C. Pahl

**MITTE** Oberwallstrasse 12
U-Station: Hausvogteiplatz
**tricia-c-pahl.com**

When Angelina Jolie and Claudia Schiffer stay in Berlin, they go to Tricia C. Pahl. The best mani/pedi in the whole city—the owner is from Brazil and knows how to make feet look perfect.

# Delfi Parfuemerie & Kosmetik

**CHARLOTTENBURG** Kurfürstendamm 46
U-Station: Uhlandstrasse
**parfuemerie-delfi.de**

A long-established cosmetic store on Ku'damm with a large selection and, above all, a very knowledge-able staff. Among other items, you can purchase Bioeffect, the Finnish miracle serum against wrinkles.

# Birga Hauptman Berlin

**CHARLOTTENBURG** Giesebrechtstrasse 3
U-Station: Adenauerplatz
**microdermabrasion-berlin.de**

I recommend this address for microderm-abrasion. Every now and again, one should allow oneself such a treatment, from the age of forty onward. The skin's appearance is much better afterward.

# Belle Rebelle

**CHARLOTTENBURG** Bleibtreustrasse 42
S-Station: Savignyplatz
**bellerebelle.de**

Select fragrances by Byredo and Blood
Concept, as well as the well-known hair oil by
David Mallett and face care and cosmetics
by Laura Mercier (the best tinted daytime
cream!). Those who have been to New York
know Aedes de Venustas—their candles and
room sprays are wonderful.

# Hairdressers

## Robert Stranz

**MITTE** Almstadtstrasse 48
U-Station: Luxemburg-Platz
**robertstranz.com**

## Shift Friseure

**CHARLOTTENBURG** Grolmanstrasse 36
U-Station: Uhland Strasse
**MITTE** Neue Schönhauser Strasse 8
U-Station: Weinmeisterstrasse
**shift-friseure.de**

## Max Höhn

**MITTE** Schröderstrasse 12
U-Station: Rosenthaler Platz
**maxhoehn.de**

Max Höhn

Wolfgang Zimmer

## Shan Rahimkhan

**MITTE** Markgrafenstrasse 36
U-Station: Hausvogteiplatz
**CHARLOTTENBURG** Kurfürstendamm 195
S-Station: Savignyplatz
**shanrahimkhan.de**

## Wolfgang Zimmer

**MITTE** Rosenthaler Strasse 36
U-Station: Weinmeisterstrasse
**wolfgangzimmer-friseur.de**

## Beate Kahlcke

**MITTE** Luisenstrasse 40
U-Station: Friedrichstrasse
**beatekahlcke.de**

# Massages

## Adlon Day Spa

**MITTE** Behrenstrasse 72
U-Station: Brandenburger Tor

**kempinski.com**

## Cowshed Spa

**MITTE** Torstrasse 1
U-Station: Luxemburg-Platz

**sohohouseberlin.de/cowshed**

## Die Wohlfühler

**PRENZLAUER BERG** Kollwitzstrasse 75
U-Station: Senefelderplatz

**diewohlfuehler.de**

## Pat's Thai Massage

**MITTE** Torstrasse 176
U-Station: Rosenthaler Platz

**traditionelle-thaimassage-berlin.de**

## Lotus Thai Massage

**MITTE** Zionskirchstrasse 34 and 38
U-Station: Rosenthaler Platz

**lotus-massage.de**

# Perfume Shops

## Frau Tonis Parfum

**MITTE** Zimmerstrasse 13
U-Station: Kochstrasse
**frau-tonis-parfum.com**

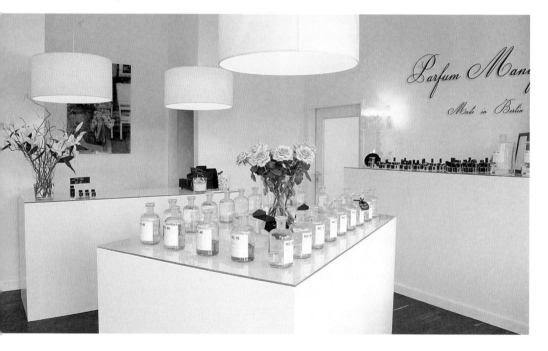

Not only can you buy Marlene Dietrich's favorite scent—Reines Veilchen (Pure Violet)—in this shop, but also they can compose a perfume according to your personal preferences.

J. F. Schwarzlose

# Harry Lehmann

**CHARLOTTENBURG** Kantstrasse 106
U-Station: Wilmersdorfer Strasse
**parfum-individual.de**

Perfume by weight since 1926: More than fifty types are ready to be sniffed in open flagons on the counter: Neroli, Vetiver, Frangipani… The old and rare scents like lily of the valley, carnation, or ambergris are especially interesting. Each customer can create her own personalized perfume combination.

# The Different Scent

**MITTE** Krausnickstrasse 12
U-Station: Weinmeisterstrasse
**thedifferentscent.de**

Discover niche scents by companies steeped in tradition, such as Annick Goutal, Carthusia, and Floris. Men will find all the accessories for a classic shave here. Old-school!

# Biehl Parfümkunstwerke

**MITTE** Borsigstrasse 8
U-Station: Rosenthaler Platz
**biehl-parfum.com**

Thorsten Biehl presents the creations of top perfumers, such as Mark Buxton, Geza Beautiful, Arturetto Landi, Egon Oelkers, Patricia Choux, and Henning Biehl in his olfactory gallery. Very exclusive!

# J. F. Schwarzlose

**schwarzloseberlin.com**

In the nineteenth century, J. F. Schwarzlose Söhne was quite simply THE number one city perfumery and, moreover, Court Supplier of His Majesty the Emperor and King. Since then, the traditional brand has been successfully revived by three young people. Scents like Treffpunkt 8 Uhr, Rausch, and Trance are new interpretations of perfume concepts from the 1920s. They are sold at various retailers and are also available through their online shop.

# Yoga in Berlin

When I moved to Berlin from the yoga paradise of Los Angeles in 2004, this Far Eastern discipline had not really come to Berlin yet. These days, Berlin is the yoga capital of Germany. There are big and small studios in which different styles, from Bikram to power yoga, are taught. And now, the better fitness centers offer classes in which one can learn everything from the sun salutation to the warrior pose. I will happily roll out my mat here:

## Spirit Yoga

**MITTE** Rosenthaler Strasse 36
S-Station: Hackescher Markt
**CHARLOTTENBURG** Goethestrasse 2-3
U-Station: Ernst-Reuter-Platz
**ZEHLENDORF** Martin-Buber-Strasse 23
S-Station: Zehlendorf
**spirityoga.de**

Patricia Thielemann is the yoga queen of Berlin. She owns and instructs in three yoga studios located in the city center, Charlottenburg, and Zehlendorf. Her motto: "Think Big." The Spirit studios not only offer a great deal of space to the yogis during their Vinyasa Flow session, but they are also tastefully furnished. They are each in top locations and in Charlottenburg there is even a spa. Patricia trains a host of yoga instructors whose teaching quality is excellent.

## Jivamukti Yoga

**MITTE** Brunnenstrasse 29
U-Station: Bernauer Strasse
**KREUZBERG** Oranienstrasse 25
U-Station: Kottbusser Tor
**jivamuktiberlin.de**

Originally developed in the 1980s by David Life and Sharon Gannon in New York, the lively Jivamukti style made its debut in Berlin a few years ago thanks to the wonderful director Anja Kühnel. Jivamukti is practiced with loud pop and rock music. And yes, the fact that the entire class sings along is part of the program. Jivamukti not only means yoga, but is also a lifestyle. As part of the Jivamukti lifestyle, among other things, participants do not eat meat and are often vegan.

Spirit Yoga

# Ashtanga Yoga

**MITTE** Brunnenstrasse 185
U-Station: Rosenthaler Platz
ashtangayogaberlin.com

The city center has become a true yoga nest in recent years. As a result, one is now also able to practice Ashtanga yoga, which is my favorite above all others because of the great discipline one must have to complete the practice of the so-called "Primary Series."

# Home Yoga

**MITTE** Friedrichstrasse 122
U-Station: Oranienburger Tor
home-yoga.de

Those who are in search of good classes in a beautiful location with an even more beautiful view from huge windows will find their new favorite studio at Home Yoga. Many of the instructors have

been trained in Jivamukti. Vinyasa classes for various levels of expertise, as well as meditation, yoga for the back and joints, and Kundalini yoga are all on the schedule.

# Yoga Tribe

**MITTE** New Schönhauser Strasse 16
U-Station: Luxemburg-Platz
yogatribe.de

With Anusara yoga, the focus lies on the opening of the heart and the precise alignment of the body. Those who learn the basics here will be armed in the future for nearly every yoga course. I have trained as a dancer so this style inspires me very much. Annette Söhnlein is a shining example of how much fun and joy yoga can bring out when a talented instructor is found.

# Yoga For All Mankind

**MITTE** Brunnenstrasse 191
U-Station: Rosenthaler Platz
y4all.com

The yoga sessions here begin at 7:30 or 9:00—perfect if one is an early riser or wants to practice the inclined plane pose before work. Generally speaking, the class schedule is directed around the lives of modern city-dwellers; so, there are not only "Happy Lunch" sessions, but also after-work classes. My favorite is the one on Sunday evenings.

# Namaste
# Yoga Gear

## Relaxed yoga clothing and accessories:

I recommend a *black-and-white tank top by Schiesser* (schiesser.com)—pure and simple, without lotus blooms or OM prints—as well as *black or light gray yoga leggings by American Apparel* (americanapparel.net). They have a high cut that will keep your bottom from peeking out during the downward dog pose.

Instead of jewelry: bright red toenails with *BER polish* (named after the incomplete Berlin airport) or, even smarter, in a *neon orange LUY* by Uslu Airlines (usluairlines.com). My favorite yoga mat is the *Superlite Travel Mat by Manduka* (manduka.com) in gray, as it's not heavy or slippery. Otherwise, there are nice things such as tops and warm-up suits for the entire body at *Pro Danse* (Alten Schönhauser Strasse 16, prodanse-shop.de), a specialty shop for ballet, dance, and fitness.

## Even more *Omm*lineshops:

### yogistar.com
Fashion and accessories, from Buddhist prayer beads to yoga blocks. Also offers Pilates equipment.

### wellicious.de
Quality yoga, Pilates, and lounge wear. Modern cuts and nice colors, from neon to pastel.

### lululemon.com
Shopping heaven for yoga and running fans. Smart sports bras and yoga mat bags.

### yogamatters.de
Large selection of clothing, accessories, and beauty products. They also carry DVDs and yoga books. The Asquith London label makes particularly nice things.

### kamahyoga.com
High-quality yoga and Pilates clothing.

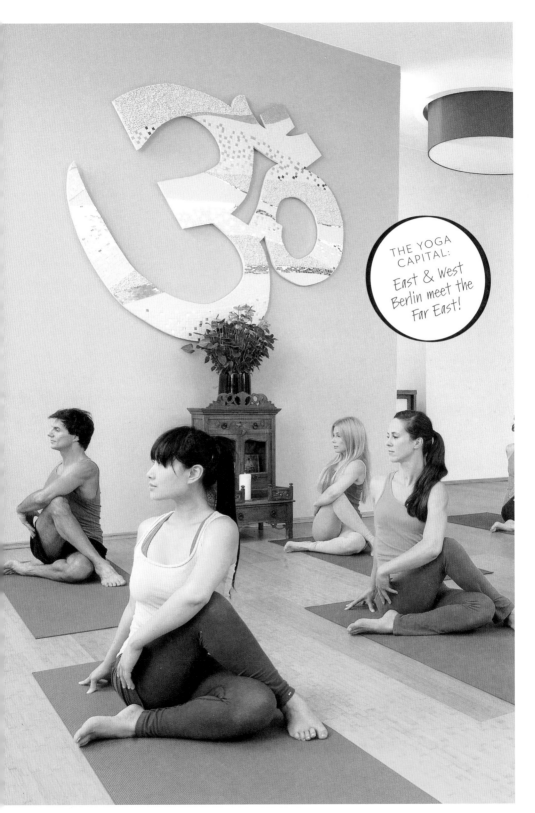

THE YOGA
CAPITAL:
East & West
Berlin meet the
Far East!

PART 3

# The BERLIN Woman at Home

BREEZY BERLIN
APARTMENTS:
Absolutely loads of
light & bright
whites!

# MY LITTLE APARTMENT

Whether the Berlin woman lives in an old building,
a modern apartment, or a loft, she loves it to be
unscripted but comfortable. She needs a retreat where
she can work in peace and where she can indulge in
daydreaming. In terms of interiors, the same applies
as with outfits: Don't be too perfect or too posh.

Timeless Furniture, Individual Decor 140
Make Room in Your Closet! 144

# Timeless Furniture, Individual Decor

The Berlin woman loves to furnish her "empire." Beautiful dwellings need not cost a fortune—one only needs to know a few tricks to create a great deal of atmosphere with little expenditure. Here are a few important ideas to keep in mind when furnishing your own place:

## Patina

The Berlin interior is like Berlin fashion—always a tad rough, robust, and solid. The flooring need not be flawlessly sanded and polished to a bright luster. On the contrary, hardwood flooring that is only oiled is beautiful. If it is stained, an excellent product to use is Slipper Satin by Farrow and Ball.

## Walls

Unplastered walls, even bare stone, are better than wood-chip wallpaper. One should look for apartments that have smooth plaster walls. Otherwise, simply renovate them yourself. The Berlin woman knows her way around a home improvement store as well as she does around the the shoe department in KaDeWe.

## Wood

A central element of a typical apartment in an old building is a large wooden table. It is worked on, eaten on, and perhaps sometimes made love on. It must be solid, preferably made of German oak, with wood or metal legs. An appropriate banquette or a collection of painted bar stools and designer chairs, like those from Hay, Thonet, Jacobsen, Eames, and Wegner, should stand around the table.

## Sleep

Beds are important because sleep is essential in a thrilling city like Berlin. People place great value on "quality sleep": no pull-out sofa, but rather a good mattress with fine bedding. Untreated linens are super-fine and feel absurdly good next to the skin. I cover my Heide Stapelbett bed with them, and it looks first-class. The best address for natural, inexpensive linens: Babie Lato (PRENZLAUER BERG Schönhauser Allee 182a, babie-lato.de).

## Good and cheap

A sitting room table from euro pallets, a shelf from old wine boxes, naked light

bulbs with colored cables—the Berlin woman may not have a great deal of money but she is a master at improvising. Renovate the kitchen over the weekend? No problem.

## Plunder

Whether it's a flea market or estate sale, the Berlin woman searches out unique pieces that she incorporates into her apartment. It could be Grandma's sideboard or an old makeup table that is revamped and looks cool next to an Eames lounge chair. The mix makes it chic!

## A dab of color

DIY is quite big in Berlin. A typical German brass chandelier looks terrifically modern if it is painted black or neon pink or powder-coated with primary colors. You can make a great dining table from construction timber with friends, and thanks to new upholstery, an old armchair becomes the highlight of the living room. Motto: From old comes new.

## Flowers

The Berlin woman prefers fresh-cut flowers and does not like stuffy flower arrangements or indoor plants such as green lilies or a yucca palm. A vase from the flea market with a few chestnut branches in it or a jug with a bunch of ranunculus quickly transforms the room. Flowers and branches are primarily bought at the market or at a trusted florist.

## Souvenirs

China, Italy, or India: I have brought back ceramics from all of the countries that I have traveled to in my life. A handmade faience bowl from Sicily is a good style break if the interiors are otherwise rather modern. Lemons look fantastic in such a bowl. My guests always want to know immediately: "Where did you get this from?" It's a great conversation starter.

## Mmm, scented candles

I don't bring palm oil candles that are harmful to the climate or those with synthetic substances into my house. My favorites are the candles by Comme des Garçons. They smell really nice thanks to the essential oils, but induce no headaches. Also, the candles by the British company Parks contain 100% natural wax and can be found, for example, in the beauty concept store Wheadon (p. 123).

## Design classics

Incorporate these with pleasure—but as with fashion, maintain a mix between the luxurious and affordable. I own several original mussel lamps from the "Fun" series by Verner Panton from the sixties and a chair by Wirkkala and Laverne; nevertheless, my apartment is not filled with only carefully styled pieces. I decorate my cognac chairs by Eero Aarnio with a hand-embroidered pillow from Romania by International Wardrobe (p. 94)—this is the "Angelika Look."

## Heaters

Radiators are often eyesores in apartments. I have disguised them in my apartment with custom-made white wickerwork à la Thonet. An optimal solution!

## Pictures

Rather than filling every available space with framed art, I only allow a few pictures by Martin Eder, Sergei Jensen, or Thomas Struth to be scattered throughout the interior spaces. In addition, I will change out the pictures over and over again. Nothing is forever.

## Live with art

One should not think of art as merely pictures. A white porcelain vase in the shape of a puppy by Jeff Koons, a dress form with a felt dress by Andrea Zittel, a concrete radio Weltempfänger (world receiver) by Isa Genzken, and a chandelier by the Californian artist Pae White are artistic but not too museum-like. I live with and among my art and preferably buy works from young artists.

*Tip:* Frame your purchases from a museum shop! And not just posters. For example, I have bought and framed a Louise Bourgeois dish towel with the words "Be Calm" from the Tate Modern.

## Nibbles

An apartment can be very nice, but it has no charm without hospitality. I always offer something to my guests: a raspberry and chocolate tartlet, a falafel sandwich from the nearby Lebanese restaurant, or fresh fruit, like apple and orange pieces that I sprinkle with lemon and serve with cinnamon and raisins. Add a pot of tea and a big bottle of still water and everyone immediately feels welcome.

## Pretty cups in the cupboard

You have surely already noticed: I am a tea fan. For me, the components of enjoying tea are a good tea kettle, a timer (green tea must be steeped for exactly two minutes in hot water at 158° F), and a tea set, such as one with a netted cobalt decoration from the Imperial Porcelain Factory in St. Petersburg (previously the Porcelain Factory Lomonosov) or the Neuosier service by KPM. The choice depends on the type of tea or time of day. Even staunch coffee drinkers will revel in happiness while enjoying a cup of tea like this.

## Last, but not least … the bathroom

I offer my guests small, uniform, colored guest towels that lie in a stack next to the washbasin, as well as the pretty, bright-pink glycerin soap Melograno by Ortiga.

Beyond paintings:
Decorate your place
with many types of
art—not just what is
framed on your wall.

# 10 + 1
## TIPS

# Make Room
# in Your Closet!

# 1. Clear out.

I clean out my closet often. To me, creating room means there is space to grow—I can either purchase new items or rediscover what I already own. My old clothes have ended up in many of the wonderful vintage stores in Berlin (p. 98) where you can buy well-preserved name-brand and designer clothes; it's the exclusive version of a second-hand store.

# 2. Preserve treasures.

A few select items have accompanied me for decades. My first expensive designer item was a Helmut Lang suit that I paid for with my first salary in Cologne in 1987. Also still hanging in my closet are two coats from my grandma Dodo: a loden coat with decorative silver buttons and a bright red coat.

# 3. Drawer logic

My wardrobe is quite organized—there are separate drawers for gloves, belts, glasses, hosiery, tights, bras, trousers, bikinis, silk scarves, etc.

# 4. Close at hand: yoga clothes

An entire compartment in my closet is dedicated to my yoga clothing—a stack of pants lies harmoniously next to a stack of tops and my wrap-around cardigans are at the ready… after all, I practice yoga almost daily!

## 5. Sweaters sorted by type

The long-sleeve pullovers hang on the left and the short sleeves are on the right, then there is one stack of turtlenecks and one of V-necks. Almost everything is black, so they need to be carefully arranged—particularly since without glasses in the morning, I can barely see anything!

## 6. Blouses and tops sorted by color

Blouses and tops hang on the two upper rods in an additional closet; this is my treasure box for going-out tops. In the evening, I just need a little silver or gold shimmery blouse or sequin top thrown over jeans and off I go!

## 7. Best-of jackets

I keep my short jackets in the lower part of that closet. Ninety percent of them are black blazers. But there are so many different variations. My favorite item is my smoking jacket from the first collection by Tom Ford for YSL.

## 8. Stars in the closet: coats

The first two seconds of a meeting are vital and I am usually still wearing my coat. So, I am courageous and fashionable when it comes to coats! My beauties are a bright red egg-shaped coat by Raf Simons for Jil Sanders, a Missoni cape, and a Valentino brocade coat. My closet is also filled with twenty black coats in different cuts. I have almost never made a bad coat purchase!

# 9. A wild card: shoes

I choose shoes to reflect my mood. I think that shoes are the most exciting part of an outfit. I clean out my shoe collection often because unfortunately I make a lot of bad shoe purchases, especially when it comes to the height of the heel. I keep my shoes in three rows at the bottom of the closet, sorted according to season and heel height.

# 10. Don't forget to care.

Make sure to carefully store and clean your clothing to keep it in excellent condition. My coats and blazers hang on wide wood hangers; my blouses hang on metal hangers, but not those from the dry cleaners—find some that are a little thicker (and nicer). I almost exclusively wear natural fabrics of the best possible quality. They do not take on dirt and odors as quickly as synthetics, and so do not need to be washed as frequently. They are ready to go after a quick airing out. I exclusively use liquid organic detergent since I cannot stand the smell of normal detergents or any fabric softener! For my dry cleaning, I only go to a high quality establishment: Jeannette Conradts (CHARLOTTENBURG Kurfürstendamm 110).

**MY TIP:**

Invest in a clothes brush made of horsehair and bronze wire (available through the Manufactum website, for example) and free your woolen clothing from pilling, shedding, and lint.

# +1. Nothing to wear?

Ask yourself which five pieces you would take to a deserted island—try to create three different looks from these five pieces. This helps you see which pieces are worn too much, how you can be creative with your favorite pieces, and what you are truly lacking in your wardrobe that could add variety to what you already own!

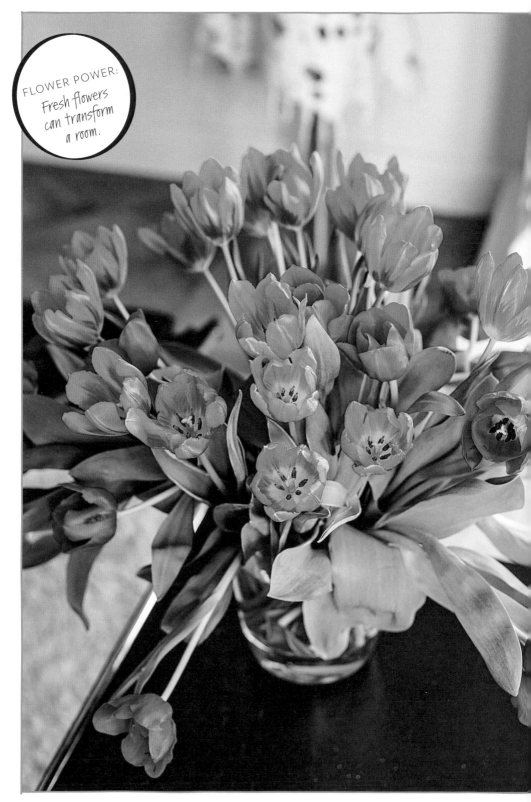

FLOWER POWER:
Fresh flowers
can transform
a room.

# THE BERLIN LIFESTYLE

Books and fresh flowers are two crucial details that add life,
beauty, and personality to a home, which are important
aspects in a space that plays so many roles. The Berlin
woman sees her home not only as a refuge, but also as a
place of business and the setting for intimate gatherings
of friends and colleagues. The key of the Berlin lifestyle
is to create a home that is flexible and inviting.

Flowers for All Occasions 150
Beautiful Browsing 154
Home Office 157 · Hosting a Party 158

# Flowers for All Occasions

Good flower shops are quite scarce in Berlin. When in doubt, I prefer to buy one or two bunches of cut, seasonal flowers rather than an arranged bouquet. These are my favorite addresses!

## Brutto Gusto— The Flowershop

**MITTE** Torstrasse 175
U-Station: Rosenthaler Platz
**bruttogusto.com**

Brutto Gusto belongs among the handful of new flower shops in Berlin that sells no gerbera or colored asters. Instead, one finds rare thistle types here along with amaryllis or small cyclamens that flourish on a clod of soil without water. A variety of sculptured vases are at home among these rare blooms.

## Blumen–und Gartenkunst

**MOABIT** Alt-Moabit 21/22
U-Station: Turmstrasse
**blumen-und-gartenkunst.de**

If I happen to drive past this shop in the summer, I will always make a stop— the display in front of the door is so beautiful! Wildflower bunches are the thing to get here and, even better, the prettiest plants for the balcony. Then my green thumb really starts to itch…

# Villa Harteneck

**GRUNEWALD** Douglasstrasse 9
S-Station: Grunewald
**villa-harteneck.de**

Villa Harteneck is a concept store for luxury interiors beautifully situated in a neo-classic villa. The selection of furniture and accessories is one of the finest. A bouquet of flowers is more affordable here, but just as tasteful. Those who do not have the time or do not feel like venturing out may order something online, like a hostess-gift for a dinner party.

# Department Store

**MITTE** Friedrichstrasse 71
U-Station: Französische Strasse
**quartier206.com**

You won't just buy designer fashion and the occasional great beauty product in this lifestyle temple—there are also beautiful little bouquets to decorate the home or to give as a gift. The owner, Annemarie Jagdfeld, can be counted among the best-known interior designers in the city!

# Marsano

**MITTE** Charlottenstrasse 75
U-Station: Kochstrasse
**marsano-berlin.com**

Some of the best lodgings in the city, from the Hotel de Rome to the Amano Hotel, are among Marsano's customers. The selection of cut flowers is excellent—when does one ever get fresh calendula? The items that form the appealing interior decor of the shop can be purchased and include vintage Danish teak sofas, jewelry chests, and neo-baroque parrots.

## TIP

Have flowers delivered to your home! At Bloomy Days (bloomydays.de), there is a flower subscription starting at €19.90, including shipping. A great idea and the selection is always truly lovely. Look for similar services in your area.

# Beautiful Browsing

The Berlin woman reads in a café, on the streetcar,
in the park, in the bathtub, and with Sunday breakfast.
Books and magazines are like food!

## Do you read me?!

**MITTE** Auguststrasse 28
U-Station: Rosenthaler Strasse
**Reading Room and Shop:**
**TIERGARTEN** Potsdamer Strasse 98
U-Station: Kurfürstenstrasse
**doyoureadme.de**

A select assortment of magazines and
books from all over the world—a simply
unbeatable international selection.

## Motto Berlin

**KREUZBERG** Skalitzer Strasse 68
U-Station: Schlesisches Tor
**mottodistribution.com**

A gold mine for select art books,
magazines, fanzines, catalogs, and
essays, hiding in a Kreuzberger
backyard.

Ocelot

## Ocelot

**MITTE** Brunnenstrasse 181
U-Station: Rosenthaler Strasse
**ocelot.de**

Their motto is truth in advertising: "Not just another bookstore." Moreover, the coffee there is tasty.

# Buchhandlung
# Walther König

**MITTE** Am Kupfergraben 1
S-Station: Hackescher Markt
**buchhandlung-walther-koenig.de**

The ultimate in art books! With additional branches in the Berlin museums: Bode Museum, Martin-Gropius-Bau, and the Hamburger Bahnhof Contemporary Art Museum.

# Gestalten Space

**MITTE** Sophienstrasse 21
(Sophie-Gips-Höfe)
U-Station: Weinmeisterstrasse
**gestalten.com/space**

Books and the best design ideas to give as gifts—the ultimate in lifestyle!

Gestalten Space

Bücherbogen

# Bücherbogen

**CHARLOTTENBURG** Stadtbahnbogen 593
S-Station: Savignyplatz

**buecherbogen.com**

This is an international, modern second-hand bookshop with a focus on architecture, art, photography, film, and design. This legend has an additional branch in the Neuen Nationalgalerie (Potsdamer Strasse 50).

# Shakespeare and Company

**WILMERSDORF** Ludwigkirchstrasse 9a
U-Station: Hohenzollernplatz

**shakespeareandcompany.de**

Valuable one-of-a-kind and first editions: the absolute best in literature!

# Kohlhaas & Company

**CHARLOTTENBURG** Fasanenstrasse 23
U-Station: Uhlandstrasse

**kohlhaasbuch.de**

A bookstore in a literature house with a fantastic selection: great for creative inspiration! (Literature houses are institutions common throughout Germany. Generally they are staffed buildings devoted to literature that offer services such as a regular reading series open to the public, and they may house writers-in-residence, the editorial offices of literary magazines, cafés, etc.)

# Coledampf's & Companies

**KREUZBERG** Am Moritzplatz, Prinzenstrasse 85d, U-Station: Moritzplatz

**coledampfs-and-companies.de**

Cookbooks for every taste, plus you can shop for a new saucepan or high-quality knife as well.

# Home Office

The Berlin woman gladly works from home, particularly since many people, myself included, are self-employed, whether they be writers, artists, designers, musicians, or the like. The primary challenge is not deciding what to wear; above all, it's time management. So while my typical outfit wouldn't be appropriate in an office, my other tips for creating an efficient work environment are still relevant no matter where you work. As I work:

* *My typical outfit includes:* Cashmere jogging pants or a pair of prettily printed silk boxer shorts, a cozy boyfriend pullover by J.Crew, and my reading glasses by Mykita, as well as the all-important fur moccasins by Ugg, with no socks!

* On the table, there is always a big *bottle of still water* for me, and a nice glass from Iittala or Orrefos (vintage). Those who do not drink enough water will have poor concentration. Drink a glass of water every hour to improve your efficiency.

* First of all, make a *to-do list* every morning. Even if there are no urgent deadlines, nothing is more unsatisfactory than an unproductive work day.

* You can buy *Mozart for Your Brain* on iTunes. You will be surprised by the effect that classical music has on your concentration.

* *Fresh flowers* in a terrific vase create a better atmosphere. Instead of beguilingly fragrant lilies or hyacinths, I recommend red tulips or thick yellow chrysanthemums, depending on the season; both look cheerful and pure in large quantities in a large glass vase.

* I write in my calendar with a pencil. Thank-you cards (from Smythson London, RSVP, or Hello Petersen) and letters, however, are always written with my silver pen with *blue ink from Montblanc.*

* Clean up your work area every evening. Above all, *tidiness* is key to efficiency!

# Hosting a Party

Berlin nightlife is legendary and the choice of restaurants, clubs, and events is tremendous. Nevertheless, everyone is pleased if they are invited to a private party at someone's home because networking occurs there like nowhere else. When the Berlin woman invites guests to dinner, no one expects a five-course menu. A few guests will always come too late anyway because they were stuck at the office or the children would not fall asleep. So, it's best to assemble an uncomplicated buffet instead. It can look something like this:

* At a catering company (my favorite caterer is called Zagreus Projekt, zagreus.net) order snacks, salads, and soups.

* Order a sushi assortment from a favorite Asian restaurant, such as Dudu (p. 185). Don't select just fish, but also choose a few vegetarian options alongside.

* Brezen (pretzels) and butter is a nice snack, paired with an ice-cold German Riesling. The Brezel Company also has excellent cakes and pastries (NEUKÖLLN Lenaustrasse 10).

* Instead of tomatoes and mozzarella cheese, it's better to dish up mezes, such as Turkish hors-d'oeuvres like olives, dips, hummus, and flatbread.

* Lentil soup: The Berlin woman adores home cooking, like a simple, comforting soup, which is easy to prepare ahead of time and keep warm. Those who wish may also serve würstchen (German sausage) with mustard.

* Champagne and cocktails need not be served. Wine, beer, and water— everyone is happy.

✱ How do I invite people? By e-mail. The Berlin woman sits at the computer all day and can confirm or invite very quickly. Naturally, I call good friends personally.

✱ Who is on my guest list? A mixture of friends, artists, and Berlin movers and shakers from the media, film, and fashion industries. I will happily play matchmaker personally as well as professionally.

✱ My nicest party? A pre–New Year's Eve party on the 30th of December. The guests were delighted that the stress over the turn of the year had been deferred and that they could see everybody two nights in a row. Just how does one celebrate in Berlin? Without rules!

✱ What do I wear? If I throw the party at my home, then I might wear a silk party dress by New York designer Maria Cornejo, or Jakub Polanka from the Czech Republic.

✱ What is a good host gift? I myself will happily bring a book that matches the host's tastes or something that can be laid directly on the table: fresh-baked bread, local honey, or something else similar.

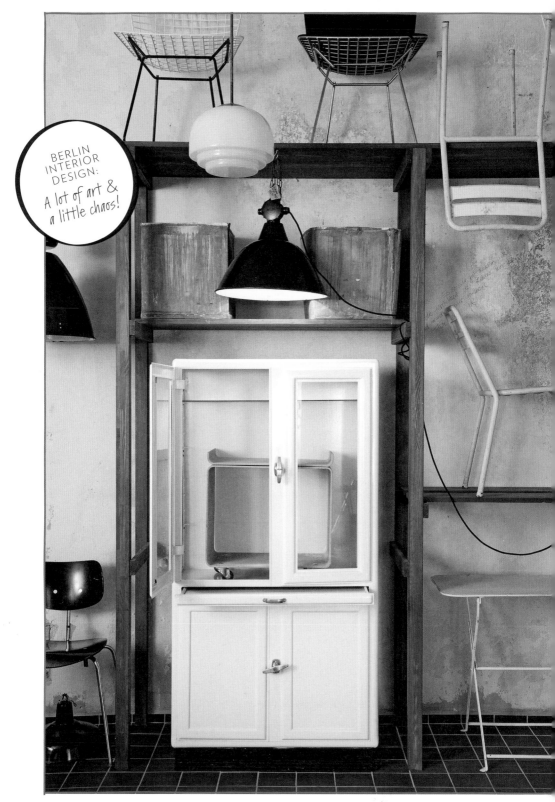

BERLIN
INTERIOR
DESIGN:
A lot of art &
a little chaos!

# LIVING DESIGN

## The best Berlin decor and interiors addresses

A lot of design and art and a little chaos—Berlin interior design reflects the attitude of the city. Those who are searching for inspiration or would like to fill their home with a little piece of Berlin should know these addresses.

Furniture 162 · Carpets 167
Accessories 168
Nice Clicks 172 · Online Shopping 173

# Furniture

## Appel Design Gallery

**MITTE** Torstrasse 114
U-Station: Rosenthaler Platz
**appel-design.com**

Tilmann Appel has exhibited design
objects from the twentieth century
for eight years. Alongside legends like
Dieter Rams (to whom an entire annual
exhibition has been dedicated), he also
displays young talents. The gallery
is recast four times a year. Even *the*
sports car of the eighties, a Lamborghini
Countach, has been parked in the
gallery showroom.

# Möbel Horzon

**MITTE** Torstrasse 106
U-Station: Rosenthaler Platz
**modocom.de**

Shelving is the star here. The "Modern" design by Rafael "Raffi" Horzon is as simple as it is brilliant. The universal shelving varies by height, width, compartmentalization system, and materials (MDF panels, light or dark birch plywood) and with a starting price of 110 euro, it is available at a comparatively inexpensive price.

# Objets Trouvés

**MITTE** Brunnenstrasse 169
U-Station: Bernauer Strasse
**objets-trouves-berlin.de**

Those who want a large dining table or a lamp with industrial charm will find them at Objets Trouvés. Alongside Eiermann chairs, Bertoia wire chairs, and metal filing cabinets are pieces of old gymnastics equipment covered with leather (many people will remember these from school sports), which make excellent benches for hallways. This is called upcycling!

# Marron Hay Berlin

**MITTE** Auguststrasse 77/78
S-Station: Oranienburger Strasse
**marronberlin.de**

Attention: Beware a buying frenzy here!
There are excellent designs of good
quality at affordable prices in this shop.
The secret to this Danish label's success
lies in clean lines combined with subtle
colors. The Berlin woman loves the J77
chair—especially in white or concrete
gray—and the colorful Kaleido trays.

# Chairs

**PRENZLAUER BERG** Fehrbelliner Strasse 25
U-Station: Senefelderplatz
**chairs-design.com**

If one is in search of an Arne Jacobsen
original or an Eames armchair from the
seventies, then this corner shop, owned
by Said Sennine and specializing in
classic design, is not to be missed. You
can also rent a small apartment in the
district through Chairs—*the* alternative
to a hotel!

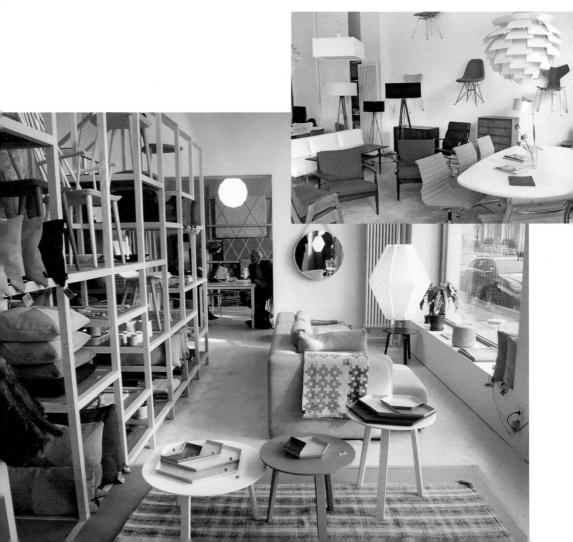

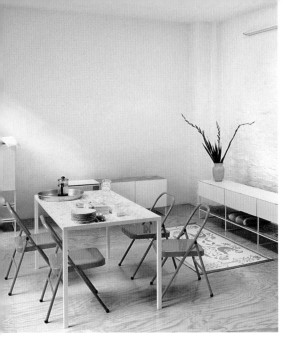

## Neue Tische

**PRENZLAUER BERG** Danziger Strasse 47
U-Station: Eberswalder Strasse
**neue-tische.de**

The opposite of the rustic oaken table can be discovered here: a steel-frame construction with a narrow tabletop that is striking and extremely elegant. I am a fan of matte powder coating! The sideboards are also great.

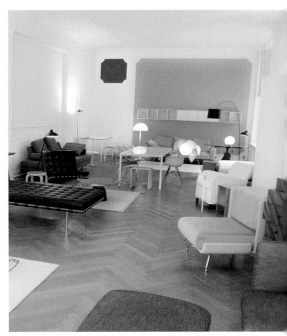

## Modus Möbel

**CHARLOTTENBURG** Wielandstrasse 27
U-Station: Adenauerplatz
**modus-moebel.de**

Modus is a furniture dealer that I trust. All of the good brands are represented here, from Cassina to Vitra, and the customer service is absolutely spot-on. On the website, under "Produckte," I find the "Entdeckunge" (Discoveries) section inspiring.

CREATIVE
BERLINERS
AT HOME

||||||||||||||||||||||||||||||||||||

**stilinberlin.com**
Very atmospheric and purist portraits of interesting Berlin inhabitants in their homes.

165

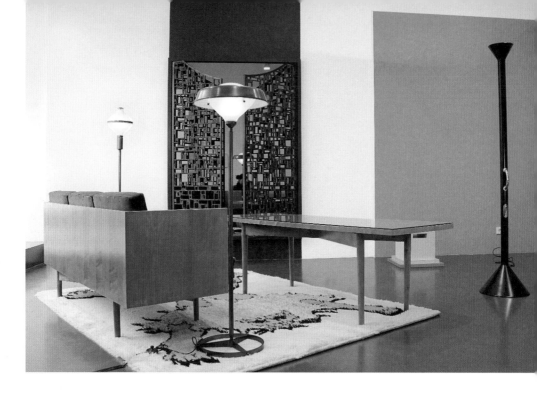

# Hans-Peter Jochum

**CHARLOTTENBURG** Bleibtreustrasse 41
(entrance on Mommsenstrasse)
**Showroom:** Knesebeckstrasse 54
U-Station: Uhlandstrasse
**hpjochum.de**

Hans-Peter Jochum concentrates on furniture pieces and objects from the fifties and sixties, particularly from Italy. All of his items are well-chosen. If he has a tulip table by Saarinen, then it will have an exceptionally veined red marble slab and black feet. Berlin's upper crust counts among the customers, as well as international greats.

# Suarezstrasse Antikmeil ("Antique Mile")

**CHARLOTTENBURG** Suarezstrasse
U-Station: Sophie-Charlotte-Platz
**suarezstrasse.com**

This street is home to more than thirty antique stores. Search for your next great find! I smell a comeback from Bauhaus and furniture pieces from the twenties. My cousin bought an enviable table-and-chair ensemble made from steel pipe and wood in one of the antique shops on Suarezstrasse. Wonderful and reasonably priced!

## Recommended…

by the *Sunday Times* and *Vogue*: For all who love clean interiors with shabby-chic details, the blog within the online shop of the same name is a bookmark must. **bodieandfou.com**

# Carpets

## Thomas Wild

**MITTE** Gipsstrasse 12 (Sophie-Gips-Höfe)
U-Station: Weinmeisterstrasse
**thomaswild.com**

This shop doesn't look like a gallery by accident—for Thomas Wild, carpets from all over the world are an art form. This trusted merchant is an expert in Tibetan prayer mats. Moreover, he offers a marvelous selection of Moroccan Berber as well as oriental carpets.

## Jan Kath

**MITTE** Brunnenstrasse 3
U-Station: Rosenthaler Platz
**jan-kath.de**

If you would like the same carpet as Bruce Willis, then you must go to Jan Kath—for him, it is not about floor coverings, but rather about "contemporary rug art." Jan Kath interprets the Persian carpet from Grandma's living room anew. Thus, the modern designer sofa fits in with the carpet—even an old Ikea sofa is given a new lease on life.

# Accessories

## KPM Quartiers

**TIERGARTEN** Wegelystrasse 1
S-Station: Tiergarten
**kpm-berlin.com**

"White gold" was a passion of "Old Fritz," Friedrich the Great of Prussia. Today, KPM is the most important German porcelain factory, alongside Meissen and Nymphenburg. I collect the Rococo design Neuosier in white from 1763—it looks as tasteful on a table as the Bauhaus design Urbino by Trude Petri, another of my favorites. Another timeless classic and, for me, a must-have: the trumpet-shaped Fidibus vase that Karl Friedrich Schinkel designed—in 1818!

## Glasklar Gläser

**CHARLOTTENBURG** Knesebeckstrasse 13
U-Station: Zoologischer Garten

Schott-Zwiesel and Jena Glass are internationally known brands made in Germany. Not only will wine and whiskey fans discover appropriate glasses and other fundamental accessories here, but purists in particular are pleased with the straightforward selection.

# Iittala

**MITTE** Münzstrasse 7
S-Station: Hackescher Markt
U-Station: Alexanderplatz
**MITTE** Friedrichstrasse 158-164
U-Station: Französische Strasse
**iittala.com**

If I need a gift, I will often go to the Finnish chain Iittala. You can get Scandinavian design at its best (tea lights, glasses, vases) here. The designs by big designers such as Alvar Aalto and Tapio Wirkkala have proven themselves year after year because they are timelessly beautiful.

# Süper Store

**KREUZBERG** Dieffenbachstrasse 12
U-Station: Schönleinstrasse
**sueper-store.de**

With the Süper Store, Vanessa Marangoni and illustrator and designer Elisabeth Scot have created a shop with eclectic offerings. The duo sells items with special charm daily—whether it be small gold stork scissors, Hammam towels, copper bowls, or Kilim pillows. The colorful hand-stitched Oya towels that come from different regions of Turkey are a stylish highlight. And you'll find a bomber jacket alongside them— this is Berlin style!

## Antike Bauelemente

**MOABIT** Lehrter Strasse 25/26
S-Station: Hauptbahnhof
**antike-bauelemente-berlin.de**

Those who are renovating and/or upgrading their apartment or house should not pass up a visit to Antike Bauelemente in Moabit. Not only will you find the tiled ovens typical of Berlin, but you'll also find antiques in the art nouveau, historicism, and art deco styles. A true gold mine and not only for the D.I.Y. crowd.

## Parkhaus

**MITTE** Schröderstrasse 13
U-Station: Rosenthaler Platz
**parkhausberlin.de**

The focus here is on colored felt accessories. For example, seat covers and pillows made from felt can prove indispensable in drafty Berlin loft offices.

## Paper and Tea

**CHARLOTTENBURG** Bleibtreustrasse 4
S-Station: Savignyplatz
**paperandtea.com**

In this jewel on Bleibtreustrasse, I sniff my way through the select Chinese tea assortment and buy paper goods; think good-luck or thank-you cards.

# RSVP

**MITTE** Mulackstrasse 14
U-Station: Weinmeisterstrasse

**rsvp-berlin.de**

Small gestures make our daily life nicer. For me, this can be a greeting written in ink or a thank-you note on one of the hand-stamped or printed cards by RSVP. In this small store, you can also find fine wrapping paper and all sorts of tasteful office supplies, like sticky notes or Japanese paper clips.

## TIP

||||||||||||||||||||||||||||||||||||

Check out the amazing website by the smart Ambra Medda, which offers magazine-style content on design along with a curated marketplace to purchase furniture, lighting, crafts, etc. larcobaleno.com

# Birgit von Heintze

**PRENZLAUER BERG** Sredzkistrasse 52
U-Station: Eberswalder Strasse

**birgit-von-heintze.de**

Aside from the all-around great service, it's a high-class address for decorative elements.

# Studio Daniel Heer

**MITTE** Rosa-Luxemburg-Strasse 26
U-Station: Luxemburg-Platz

**danielheer.com**

Hand-stitched horsehair mattresses and leather accessories for the home.

# Sophie von Seidlein

**CHARLOTTENBURG** Suarezstrasse 43
S-Station: Charlottenburg

**sophievonseidlein-berlin.de**

The most splendid fabric selection in the city.

# Raumwerk Berlin Sabrina Nordalm

**MITTE** Zehdenicker Strasse 7
U-Station: Rosenthaler Platz

**www.raumwerk-berlin.de**

A specialist for storage wall units— simply brilliant!

## Even more addresses

Ruby designliving **ruby-designliving.de**
Minimum Wohnen **minimum.de**
The Imaginäre Manufaktur DIM
**dim-berlin.de**

# Nice Clicks

The best online addresses for decor and interiors:

## * emmas.blogg.se

Emma presents interior design ideas that one wants to immediately implement within his or her own four walls.

## * freundevon freunden.com

How do hipsters live worldwide? Friends of friends pop in and share nice photos.

## * herz-allerliebst.de

A cool lady called Nadine writes about decor, photos, children, and beauty.

## * inattendu.tumblr.com

The Swiss Tine Fleischer is a graphic designer who always hits the mark with an assured selection of tasteful furniture pieces, fashion, and accessories.

## * theselby.com

What Scott Schuman a.k.a. The Sartorialist is to fashion, Todd Selby is to stylish home photography. Many Germans are among those whose houses are portrayed: Otto Sander and Monika Hansen, Wolfgang Joop… *et moi.*

## * ohhhmhhh.de

A design and do-it-yourself blog by the Hamburg journalist and writer Stefanie Luxat. Her specialty: weddings!

## * stylinrooms.de

My favorite section of this website is the "Wohnideen" or "Living Ideas": An old city house in Switzerland, a small Danish house on the beach, or a villa in Potsdam… this blog lets me dream.

## * style-files.com

Caution: The blog by Le Souk owner Danielle de Long from Amsterdam will quickly become addictive!

## * decor8blog.com

Blog by the bestselling American author and interiors stylist Holly Becker, who happens to live in Hannover, Germany.

## * saniapell.com/ athomeblog

Flower fans like me will arrange the ideas by London designer Sania Pell with great joy.

### More on the blogroll:

frenchbydesign.blogspot.de
amerrymishapblog.com
riazzoli.blogspot.com
thecontraster.com

# Best of
# Online Shopping

## Top Five

### 1. ambientedirect.com

Furniture pieces, lamps, kitchen and other home decor accessories by famous manufacturers.

### 2. bensimon.com

I shop here not only for their famous tennis shoes, but also for lifestyle and travel accessories.

### 3. cairo.de

Office and designer furniture pieces and classics by Artemide, Cassina, Thonet, or Vitra.

### 4. hellopetersen.com

Graphic designer Melanie Petersen designs posters, cards, pillows, bedding—and designed this book! I always find something entirely special from her.

### 5. fab.com

With the goal of becoming the "Amazon for Design," the site's selection is already expansive and often unique.

## Even More

Ikarus.de
madeindesign.co.uk
muji.us
muuto.com
moooi.de
warymeyers.com

## Online Auctioneers

### quittenbaum.de

Art from the twentieth century: art nouveau, art deco, Murano glass, and African art.

### herr-auktionen.de

Egon Eiermann, Le Corbusier, Eileen Gray—the eyes of design fans begin to shine at auctions with such great names.

### lauritz.com

Art, design, antiques, and luxuries, as well as jewelry and fashion. I'll only say Valentino, Chanel…

### bruun-rasmussen.dk

The family-led auctioneer that has been bringing design classics and art under the gavel since 1948.

PART 4

# Angelika's
## BERLIN

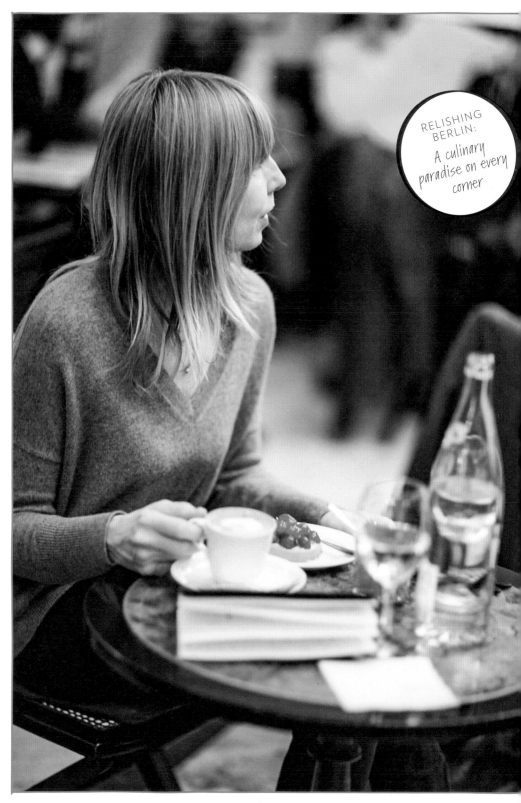

RELISHING BERLIN:
A culinary paradise on every corner

# EATING + DRINKING WELL IN BERLIN

The Berlin woman loves to discover new restaurants, and all the better if it's in the company of her friends or significant other. She will go out to eat in the evenings under the open sky in the summer. Size zero will never become a trend in Berlin since the food is too delightful. Every district offers a culinary trip around the globe. Enjoy your meal!

Tasty Clicks 178
Classics 180 · Regional and Global 184
Dine Around the World 192
Currywurst 194 · Quick Bites 196 · Cafés 200
Berlin's Sweet Side 205 · Summer Specials 206
Vegetarian Spots 208 · Bakeries 211
Bars 216

# Tasty Clicks

One can quickly run out of steam trying to explore all of the restaurants that are available in Berlin. The food bloggers, a.k.a. the foodies, who know the best restaurants from Wedding in the north down to the Steglitz area, do the legwork for you and offer essential guidance.

### * ceecee.cc

My favorite blog and newsletter! I set off immediately when a new address is introduced on Thursdays. The photos inspire my culinary imagination.

### * thewednesdaychef.com/ berlin_on_a_platter

Luisa Weiss, a cookbook editor and former New Yorker who lives in Berlin, shares her expert knowledge of food and the city. Her blog is broken down by district and categories. I like the "Berlin Eats and Reads" column.

### * stilinberlin.de/ category/food

This site by fashion blogger Mary Scherpre features a perfect mix of haute cuisine and street food, as well as shopping tips, like where to buy hot sauce. The answer: Pfefferhaus! My mouth always begins to water immediately while I'm reading!

### * foodieinberlin.com/ berlin-myfavourite-places

Suzy goes on treasure hunts in Berlin, London, and Kuwait, where her family comes from. Lovingly taken photos, personal text, and—my favorite—tasty cake recipes.

### * unlike.net/berlin

A good compilation of restaurants and hotels, as well as points of interest near the restaurants, such as galleries, movies, or theaters.

### * sugarhigh.de/ category/food

Daily e-mail magazine introducing the hot spots for art, music, fashion, food, movies, and events. The "Avoid Hangovers" section has advice on how to fight against the pains of the morning after. I can only suggest ordering the Strammer Max breakfast at Engelberg (PRENZLAUER BERG Oderberger Strasse 21)!

## * slowfood-berlin.de

Informative site on the globally trendy Slow Food movement, which aims to promote a world in which all people can access and enjoy food that is good for them, good for those who grow it, and good for the planet. Berlin is an absolute forerunner of the movement in Germany, with many initiatives and members.

## * fraeuleinkimchi.com

Canadian Lauren Lee cooks "Seoul Fusion" and reveals the best kimchi and bulgogi recipes on her website, as well as during her cooking classes.

# Not from Berlin, But Worth Reading

## * nutriculinary.com

Stevan Paul dispenses knowledge, passion, and humor. His blog has even been nominated for the Grimme Online Award. Rightly so, because his culinary anecdotes are brilliant.

## * deliciousdays.com

Nicole Stich is considered by many to be the most important German food blogger and cookbook author—she writes her text in English, which also makes her internationally successful.

## * photisserie. blogspot.com

Every blog entry by Kathrin Koschitzki is a small poem, not only through the recipe, but also the execution. A fine example of how professional bloggers work these days!

# Classics

## Grosz

**CHARLOTTENBURG**
Kurfürstendamm 193-194
U-Station: Uhlandstrasse
S-Station: Savignyplatz

**grosz-berlin.de**

### Ambience

The motto could be "The Good Old Days." Eighteen-foot ceilings, ornate columns, white tablecloths, porcelain, and gorgeous teapots. One feels as though they've stepped back into Berlin at the turn of the century. What a big-city feeling!

### Good to know

This place is historically significant. The namesake for the bar is the artist George Grosz. The Haus Cumberland is historically listed and was designed and built from 1911–12 by the architect Robert Leibnitz.

### What to order?

First of all, there are delicious breakfasts, and the bouillabaisse with scallops and crawfish is a treat for the palate. For taking home: marvelously packaged brioches and almond croissants from Patisserie L'Oui next door.

*A grand old time in the Kurfürstendamm district!*

# Borchardt

**MITTE** Französische Strasse 47
U-Station: Französische Strasse
**borchardt-restaurant.de**

## Good to know
This restaurant with a red awning is a classic among the Berlin VIP restaurants.

## Ambience
The ambience is rather conservative: marble columns, white tablecloths. When it is full, it is very lively and loud. Reserve one of the corner tables, if possible. The best seat in the house: the long table across from the bar.

## What to order?
Schnitzel as large as an elephant's ear with a fluffy breadcrumb coating. If it is in season, order the asparagus with a small schnitzel—a Berlin favorite!

## In a few words
See and be seen!

# Paris Bar

**CHARLOTTENBURG** Kantstrasse 152
S-Station: Savignyplatz
**parisbar.net**

## Good to know
The beauties and beasts from the art and movie scene feast here. Heiner Müller wrote about Paris Bar that those who enter here can give up all hope that they will leave before morning. With this in mind: Cheers!

## Ambience
Look around! The walls are filled with photographs, drawings, and paintings of artists befriended by the magnificent Michel Würthle.

## What to order?
Blood sausage with slightly warmed potato salad. I blissfully eat this with the steak frites!

## In a few words
The classic in West Berlin!

# Grill Royal

**MITTE** Friedrichstrasse 105b
U- and S-Station: Friedrichstrasse

**grillroyal.com**

## Good to know

Insiders simply call this restaurant that specializes in steaks "The Grill." The hosts love art (former architecture student Boris Radczun; the collector and framebuilder Stefan Landwehr; and gallery owner Thilo Wermke)!

## Ambience

Hollywood atmosphere in one of the last old East Germany buildings in the Berlin city center.

## What to order?

Filet steak (dry-aged for three weeks) with béarnaise sauce and sweet potato fries.

## In a few words

The most stylish steak house in Germany.

# Pauly Saal

**MITTE** Auguststrasse 11
S-Station: Oranienburger Strasse

**paulysaal.com**

## Good to know

The restaurant was previously the gymnasium in a Jewish school for girls and as a result the ceilings and windows are extremely high. The meeting point is a cozy and elegant bar in the foyer.

## Ambience

Impressive chandeliers made of Murano glass and green velvet-covered banquette seats. The big rocket above the open kitchen is called "Miss Riley" and is a piece of art by Cosima von Bonin.

## What to order?

As a matter of priority, the cooking is done with regional products. One must be open to trying offal—like a calf's heart.

## In a few words

Newcomer to the Berlin "It" Restaurants.

## Sale & Tabacchi

**KREUZBERG** Rudi Dutschke Strasse 25
U-Station: Kochstrasse
**sale-e-tabacchi.de**

### Good to know
At noon, this Italian spot is a sort of refined canteen for the employees of the surrounding publishing companies, and in the evenings one might bump into one or two VIPs from the media or art scene.

### Ambience
Classic: white tablecloths, dark wood, and leather banquette seats. The sunny courtyard is really beautiful in summer.

### What to order?
There is no pizza, but in exchange there are Italian classics such as eggplant Parmigiana—everything is always a bit more finely prepared than at the typical neighborhood Italian joint.

### In a few words
My favorite Italian!

## Tim Raue

**KREUZBERG** Rudi Dutschke-Strasse 26
U-Station: Robert-Koch-Strasse
**tim-raue.com**

### Good to know
No potatoes, no noodles, no bread, but ten-year-old soy sauce in exchange—this is really contemporary.

### Ambience
The tourist activity at Checkpoint Charlie down the road won't detract from the experience when one enters this exceptional restaurant—the food could not be better.

### What to order?
Begin with the lunch menu. A must: Tim Raue's interpretation of Peking duck.

### In a few words
Two Michelin stars!

# Regional and Global

## La Soupe Populaire

**PRENZLAUER BERG** Prenzlauer Allee 242
U-Station: Senefelderplatz
**lasoupepopulaire.de**

## Mogg & Melzer Delicatessen

**MITTE** Auguststrasse 11-13
U-Station: Rosenthaler Platz
**moggandmelzer.com**

Tim Raue has recently opened a great new restaurant in the former site of the Bützow Brewery. Surrounded by simple vintage furniture pieces, he serves regional cuisine: "Shrimp Cocktail KaDeWe," Königsberger Klopse (meatballs in a caper sauce), and cod with braised cucumbers, all on my favorite porcelain (Urbino by KPM). What a great idea!

Mogg & Melzer have found an apt location in a former Jewish school for girls (the same building that now houses the Paul Saal restaurant, as well); after all, the pastrami sandwich is a Jewish-American bestseller. Moreover, there is a Caesar salad here that, outside of one from California, best suits my taste. I like the interior: dark wood, mauve upholstered banquette seats, and Sharon Lockhart's "Lunch Box" series on the wall.

# Chén Chè Teehaus

**MITTE** Rosenthaler Strasse 13
U-Station: Weinmeisterstrasse
**chenche-berlin.de**

Berlin is a good fit for the Café-Latte-To-Go Generation. This teahouse situated in a backyard is an oasis of peace where the traditional Vietnamese tea ceremony is maintained. I recommend the chrysanthemum tea, which is good for the eyes according to Chinese medicine. The sweets, such as banana cake and rice flour pudding with mango and coconut, are delicious. An enormous cage with twittering little birds is part of the décor, along with a summer garden with colored silk pillows. Take a little break here; it's awfully nice!

# Dudu

**MITTE** Torstrasse 134
U-Station: Rosenthaler Platz
**dudu-berlin.de**

All of Berlin is crazy for the sushi creations by Nam Cao Hoai, his sister Chi, and their mother, and as a result, the shop is always in a complete uproar. Rather than dull cucumber maki, the two hipsters will serve their guests the Crunchy Dudu Rolls with salmon or a vegetarian version with a tomato salsa and guacamole. The Berlin woman swears by the restorative pho soup—one might call this a type of soul food. Those who wish can make merry afterward at the new Bonbon Bar across the street (Torstrasse 133).

# Bandol &
# 3 Minutes sur Mer

**MITTE** Torstrasse 167
U-Station: Rosenthaler Platz
**bandolsurmer.de**

This French mini-restaurant has been
humming ever since Brad Pitt once
ate there. It truly was one of the first
"In" restaurants in Torstrasse, which
has transformed into the new gastro
and fashion mile. "NoTo" ("North
of Torstrasse") or "SoTo" ("South of
Torstrasse") are the Berlin woman's
nicknames for the area in the style of
the New York district SoHo. One feels
a little like they are in the Lower East
Side, with good people-watching. If
there are no tables free, you can try
next door at 3 Minutes sur Mer.

# Lokal

**MITTE** Linienstrasse 160
U-Station: Rosenthaler Platz
**lokal-berlin.blogspot.de**

A piece of the country in the center of the
city. The atmosphere is northern-rustic
thanks to the wooden tables by designer
Katja Buchholz and the snug sheepskins
over the chair armrests. Many regional
and seasonal dishes are on the menu:
char with black salsify ("the asparagus
of the East"), organic chicken breast
with sweetheart cabbage and apples,
or roast beef with parsnips and Brussels
sprouts. Vegetarians float on cloud nine
with the oven-roasted vegetables with
quark cheese.

# Pappa e Ciccia

**PRENZLAUER BERG** Schwedter Strasse 18
U-Station: Senefelderplatz
**pappaeciccia.de**

I find this restaurant particularly nice at noon; there are classic pasta dishes such as penne Arrabiata or spaghetti Bolognese, cooked exactly like I do at home. The ingredients are organic, and vegan dishes are even specially featured on the menu.

# Clärchens Ballhaus

**MITTE** Auguststrasse 24
U-Station: Rosenthaler Platz
**ballhaus.de**

This spot is an enchanter since it is in an unrenovated building in the middle of the hip gallery mile, Auguststrasse. The small German-Italian menu offers savory dishes such as meatballs and Neapolitan brick-oven pizza—the best in all of Berlin, many people say! In summer, one can sit in the romantic garden outside and in winter, a live band or DJ will play after dinner. The restaurant then changes into a dance hall where the young and old can boogie together.

# Manzini

**WILMERSDORF** Ludwigkirchstrasse 11
U-Station: Spichernstrasse
**manzini.de**

I love to have breakfast on Sunday at Manzini. The small locale is a classic in West Berlin and is conveniently in one of the nicest areas—you can delightfully stroll all around Fasanenplatz and there are large playgrounds for the children. The club sandwich is highly recommended; I have been testing club sandwiches during my travels around the world for a long time now and know my stuff!

# Bonfini

**MITTE** Chausseestrasse 15
U-Station: Naturkundemuseum
**bonfini.de**

An absolutely unpretentious place with checkered tablecloths and candle-light—if one happened to simply be passing through, they would not guess that Bonfini is, and has long been, one of the best Italian restaurants in the city. Unfortunately, the patron, Bruno Bonfini, has passed away. I remain all the more faithful to the restaurant. What do I recommend? I love the perfectly roasted rib-eye with a simple but very fresh insalata mista. A friend swears by the spaghettini with crayfish.

# Diener Tattersall

**CHARLOTTENBURG** Grolmanstrasse 47
S-Station: Savignyplatz
**diener-tattersall.de**

White curtains, dim light, photos hanging everywhere—it's almost a little bit like Grandma and Grandpa's house. However, the people in the portraits are world stars such as Billy Wilder, Manfred Krug, and Harry Belafonte. They were all here and feasted on substantial, traditional fare like goulash soup, Palatine liverwurst, or Strammer Max with fried egg. In summer, one can sit outside on plastic garden chairs. The premises are named after the long-passed owner, Franz Diener, who was not only a former German Heavyweight Champion, but also a qualified butcher.

# The Bird

**PRENZLAUER BERG** Am Falkplatz 5
U-Station: Eberswalder Strasse

**thebirdinberlin.com**

Everyone agrees: The
best burger in the city is at
The Bird. The ambience
is low-key, but this does
not alter the mood since the restaurant is
always humming. Rightly so: Nothing comes
from the freezer or a can. Not only are the
half-pound burgers homemade and the fries
hand-cut, but the sauces and dressings are
made by hand as well.

# Henne Berlin

**KREUZBERG** Leuschnerdamm 25
U-Station: Moritzplatz

**henne-berlin.de**

This earthy Berlin corner pub has a
great deal of history: The Wall once
ran through the Henne beer garden.
In summer, one can comfortably
sit here under the lime trees, order
half a chicken with potato salad or
coleslaw (there is none better!),
and drink a freshly tapped ale. An
institution!

# Restaurant Richard

**KREUZBERG** Köpenicker Strasse 174
U-Station: Schlesisches Tor
**restaurant-richard.de**

One of my latest discoveries—and yet, it is one of the oldest establishments in Berlin. The splendid wood ceiling and the wonderful leaded windows provide evidence of its history. The unique atmosphere is enhanced with pieces of art from Araki to Pierre Klossowski (!). The owner, Hans Richard, studied painting at the University of Art and Design in Basel. And the food? A variety of three- to five-course menus with fish and meat; the two Swiss chefs also happily accommodate vegetarian requests.

# Schlesisch Blau

**KREUZBERG** Köpenicker Strasse 1a
U-Station: Schlesisches Tor
**facebook.com/schlesisch.blau**

This is typical of the Kreuzberg area: Ragtag furnishings, informal atmosphere, and simple but good food, seasoned with a pinch of chaos. In Schlesisch Blau, you can sit next to an old crackling wood stove with the soup of the day simmering on top, and you're welcome to help yourself. The four-course menu (which always includes a vegetarian main course) costs eighteen euro and is scrawled on a chalkboard on the wall. The place is loud, warm, and extremely homey.

# Restaurant Big Window

**HALENSEE** Joachim Friedrich Strasse 49
S-Station: Halensee
**big-window.de**

If you are a vegetarian, it might be best to go somewhere else, though it would be a pity to miss this establishment that opened in the sixties—it's an experience. However, the Armenian kitchen is simply rather meat-heavy, specializing in dishes like minced meat skewers on flatbread ("Lule auf Lawasch"). The secret of the sensational taste is an Indian-Oriental spice marinade that the owner, Ivan, has created. With the food, one drinks vodka that not only contributes to the playful mood, but also to the digestion. I have experienced some very, very wild evenings here.

# NEIGHBORHOOD NICKNAMES

Arranging to meet up with locals can sometimes be a challenge since a Berlin woman will shorten the addresses:

* **Boxi**    Boxhagener Platz
* **Görli**    Görlitzer Park
* **Gianni**    Gendarmenmarkt
* **Helmi**    Helmholtzplatz
* **Kutschi**    Kurt-Schumacher-Platz
* **Kotti**    Kottbusser Tor
* **Nolli**    Nollendorfplatz
* **Stutti**    Stuttgarter Platz

## *Two more exclusive tips:*

# Da Baffi

**WEDDING** Nazarethkirchstrasse 41
U-Station: Leopoldplatz
**dabaffi.com**

A small Italian restaurant in the new theater district in Wedding. About the name: In Italy, if something is mouth-watering, they say, "*Da leccarsi i baffi,*" or "I licked my mustache!"

# Fleischerei Domke

**FRIEDRICHSHAIN** Warschauer, Strasse 64
U-Station: Frankfurter Tor

Young and old make a pilgrimage to this butcher shop. The reason: lunch plates with meatballs, stuffed peppers, beef roulade, goulash noodles, potatoes, red cabbage, and sauerkraut. Like eating at your mom's!

# Dine Around the World

A culinary world trip…

## Argentina

* **La Parrilla – Argentine steak restaurant**, MITTE Albrechtstrasse 11

## China

* **Long March Canteen**, KREUZBERG Wrangelstrasse 20
* **Good Friends**, CHARLOTTENBURG Kantstrasse 30

## Germany

* **Altes Europa**, MITTE Gipsstrasse 11
* **Anna Blume**, PRENZLAUER BERG Kollwitzstrasse 83
* **Zur letzten Instanz**, MITTE Waisenstrasse 14-16
* **Vaust**, CHARLOTTENBURG Pestalozzistrasse 8
* **Ö**, KREUZBERG Mehringdamm 80
* **Drei Schwestern**, KREUZBERG Mariannenplatz 2
* **Silberlöffel**, KREUZBERG Maybachufer 21

## England

* **East London**, KREUZBERG Mehringdamm 33

## Ireland

* **The Lir**, TIERGARTEN Flensburger Strasse 7

## France

* **Mani**, MITTE Torstrasse 136
* **Le Cochon Bourgeois**, KREUZBERG Fichtestrasse 24
* **Les Valseuses**, PRENZLAUER BERG Eberswalder Strasse 28
* **Brut Bar**, MITTE Torstrasse 68

## Greece

* **Ellopia**, PRENZLAUER BERG Erich-Weinert-Strasse 55

## Italy

* **Al Contatino Sotto le Stelle**, MITTE Auguststrasse 36
* **Papà Pane di Sorrento**, MITTE Ackerstrasse 23
* **Mädchenitaliener**, MITTE Alte Schönhauser Strasse 12
* **Osteria No. 1**, KREUZBERG Kreuzbergstrasse 71
* **Lavanderia Vecchia**, NEUKÖLLN Flughafenstrasse 46
* **Il Calice Enoiteca**, CHARLOTTENBURG Walter-Benjamin-Platz 4

# Japan

* **Sasaya**, PRENZLAUER BERG Lychener Strasse 50
* **Mamecha**, MITTE Mulackstrasse 33
* **Kuchi**, MITTE Gipsstrasse 3 and CHARLOTTENBURG Kantstrasse 30

# Korea

* **Kimchi Princess**, KREUZBERG Skalitzer Strasse 36
* **YamYam**, MITTE Alte Schönhauser Strasse 6
* **Kochu Karu**, PRENZLAUER BERG Eberswalder Strasse 35
* **Ixthys**, SCHÖNEBERG Pallasstrasse 21

# Lebanon

* **Maroush**, KREUZBERG Adalbertstrasse 93

# Mexico

* **Maria Bonita**, PRENZLAUER BERG Danziger Strasse 33
* **Dolores Gourmet Burritos**, MITTE Rosa-Luxemburg-Strasse 7

# Pan-Asian

* **Transit**, MITTE Rosenthaler Strasse 68

# Sweden

* **Café Valentin**, NEUKÖLLN Sanderstrasse 13

# Spain

* **Bar Raval**, KREUZBERG Lübbener Strasse 1

# Syria

* **Yarok**, MITTE Torstrasse 195

# Turkey

* **Rosenthaler Grill & Schlemmerbuffet**, MITTE Torstrasse 125

# Vietnam

* **CôCô bánh mì deli**, MITTE Rosenthaler Strasse 2
* **Si An**, PRENZLAUER BERG Rykestrasse 36

## VERY BERLIN: POP-UP RESTAURANTS

danielseatery.com
pretadiner.com
aircuisine.de (A pop-up in the most literal sense of the word—this restaurant-within-a-plane actually goes up in the air!)

# Currywurst

Bratwurst with a sauce made from tomato paste, powdered spices, and Worcestershire sauce: Those who come to Berlin must try a currywurst at least once. Nearly every vendor boasts that they are guarding a secret recipe. There is even a Currywurst Museum (MITTE Schützenstrasse 17).

## Konnopke's Imbiss

**PRENZLAUER BERG** Schönhauser Allee 44 B
U-Station: Eberswalder Strasse

**konnopke-imbiss.de**

*The pilgrimage site for curry fans!*

# Curry 36

**KREUZBERG** Mehringdamm 36
U-Station: Mehringdamm

**curry36.de**

*The best currywurst in West Berlin!*

# Curry B

**PRENZLAUER BERG** Prenzlauer Allee, sometimes on Höhe Metzer Strasse

**boetzowberlin.de**

Currywurst from the silver caravan.

# Witty's

**CHARLOTTENBURG** Wittenbergplatz 5
U-Station: Wittenbergplatz

**wittys-berlin.de**

Everything is organic and the Belgian fries are also world-class!

# curry and chili

**WEDDING** Prinzenallee 72
U-Station: Gesundbrunnen

**curry-chili.de**

The hottest curry sauces in the city!

# Curry Mitte

**MITTE** Torstrasse 122
U-Station: Rosenthaler Platz

**currymitte.de**

For all hungry late-night revelers!

*One more tip for Wurst Fans:*

# Blutwurstmanufaktur

**NEUKÖLLN** Karl-Marx-Platz 9-11
U-Station: Karl-Marx-Strasse

**blutwurstmanufaktur.de**

Before you shriek "yuck," please try a tiny little piece. The Berlin blood sausage by the master butcher and Chevalier du Goûte Boudin ("Blood Sausage Knight"), Marcus Benser, is award-winning and seasoned with Thüringer marjoram, hand-cracked Brazilian peppers, and a little cinnamon, and is eaten with bread or sauerkraut. The blue-and-white–striped packaging is also chic. I would say: The perfect small gift from Germany!

# Quick Bites

## Markthalle Neun

**KREUZBERG** Eisenbahnstrasse 42/43
U-Station: Schlesisches Tor

**markthalleneun.de**

## Mustafas Vegetables Kebap

**KREUZBERG** Mehringdamm 32
U-Station: Mehringdamm

**mustafas.de**

Breakfast or brunch at Markthalle Neun on Sunday morning is always an adventure. There is so much to discover! Bread from Soluna Brot & Öl, smoked fish, rillettes and smoked salmon from Glut & Späne, or wine from the distributor Suff. For me, it's an absolutely perfect mixture of organic market, café, and canteen!

There is a reason there is always a line at Mustafa at any time of the day or night: The vegetarian kebab with freshly roasted vegetables and feta is a tremendous pleasure. Those who can take it will choose the hot sauce. Then afterward, try a scoop of lemon cinnamon ice cream at Vanille und Marille around the corner. Then, in my opinion, one has enjoyed gourmet food for less than ten euro!

# City Chicken

**NEUKÖLLN** Sonnenallee 59
U-Station: Rathaus Neukölln

Hot and greasy! This chicken grill is *the place* to eat for the Turkish and Arabian community. It can be found in the middle of Neukölln in the Mittleren Orient; try half a chicken with Turkish flatbread, neon pink–colored coleslaw, hummus, and a garlic sauce that could not be hotter. The antidote to the grease is the lemon juice on every table that is generously sprinkled over the food—this supposedly helps with the fat digestion.

# Burgermeister

**KREUZBERG** Oberbaumstrasse 8
U-Station: Schlesisches Tor
**burger-meister.de**

Upon laying eyes on the homemade burger patties on the grill before her, even coauthor Alexa (a vegetarian) became weak and ordered a cheese-burger, which she blissfully polished off in less than three minutes. The location—under the railway track—is delightfully metropolitan. Each patron is given a number that is displayed on a larger screen when her order is ready—while you are waiting, be sure to arm yourself with a few paper towels.

# Rossia Imbiss & Supermarket

**CHARLOTTENBURG** Stuttgarter Platz 36
S-Station: Charlottenburg

Those who would like to eat an authentic borsch soup must go to Rossia. Particularly in winter, this dish is wonderfully warming from the inside out—the Russians simply know how to best survive the cold. A tasty Baltika No. 9 beer fizzes alongside. Next door in the Russian supermarket, you can stock up on caviar, vodka, and candy to bring home. Brilliant operating hours: twenty-four hours a day, seven days a week!

# Joris

**MITTE** Brunnenstrasse 158
U-Station: Bernauer Strasse

Everybody in Berlin is familiar with baked potatoes with quark. At Joris, everything tastes especially good because the two kind chefs are well trained and prepare everything themselves. Those who wish may order the baked potato with a warm topping (vegetable curry, Texas chili, mushroom cream, smoked mustard…). The motto: "Healthy Fast Food."

Joris

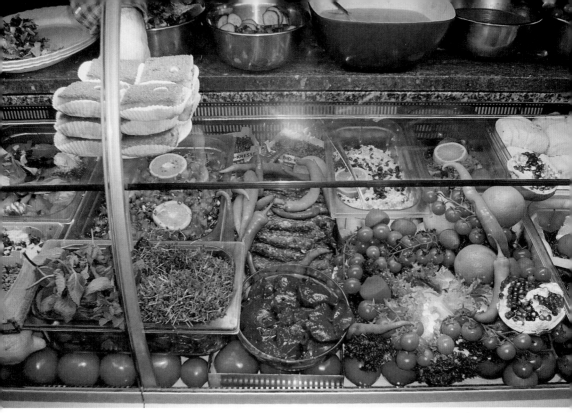

Rossia Imbiss & Supermarket

# Babel

**PRENZLAUER BERG** Kastanienallee 33
U-Station: Senefelderplatz

I am a falafel fan and have tried out many falafel restaurants, but still end up in this Lebanese restaurant on Kastanienallee time and again. The spicy chickpea balls are crisp on the outside and amazingly soft on the inside and pair perfectly with broiled vegetables, red onions, and a salad with mango sauce and mint leaves. The guys behind the counter strew pomegranate seeds all over the falafel plate—heavenly! Consider yourself warned: highly addictive.

# Yarok

**MITTE** Torstrasse 195
U-Station: Oranienburger Tor
**yarok-restaurant.de**

Yarok also offers delightful falafel sandwiches and typical Syrian food from Damascus. I have yet to have anything like their lemony special sauce anywhere else.

# Cafés

## The Barn Coffeeshop & Roastery

**MITTE Coffee Shop:** Auguststrasse 58
U-Station: Rosenthaler Platz
**Roastery:** Schönhauser Allee 8
U-Station: Luxemburg-Platz
**thebarn.de**

The local residents and employees of Auguststrasse stock up here on coffee to go and Alpine cheese sandwiches. The baristas all wear checkered shirts; if you're lucky, the attendant will speak in German. Otherwise, the English "One latte, please" applies. I especially like the coffee with the chocolate almond or lemon pound cake. The large roastery on Schönhauser Allee is about nothing but pure bean pleasure; there is neither milk nor sugar.

## Princess Cheesecake

**MITTE** Tucholskystrasse 37
U-Station: Oranienburger Tor
**princess-cheesecake.de**

Tasty, freshly baked cakes and tortes, made with mostly organic ingredients. The selection is as vast as it is tempting. The list of goodies includes New York cheesecake, tarts with fresh lemon, Russian Zupf cake, cream cheese with fresh mango, and caramel apples, as well as cream puffs and brownies with walnuts.

# Röststätte

**MITTE** Ackerstrasse 173
**PRENZLAUER BERG** Kastanienallee 45

**pro-macchina.com**

The Röststätte counts among my favorite cafés. The hand-picked coffee beans are fair trade and are roasted very sloooowly in a drum by the coffee sommelier, Ivo Weller (yes, there really is such an occupation!). While the roasting goes on in the café on Ackerstrasse, the annex on Kastanienallee invites you to linger: The big wooden table and the black Masters chairs by Philippe Starck create the typical Berlin atmosphere—cool, rustic, but unhurried.

# Café Oliv

**MITTE** Münzstrasse 8
U-Station: Weinmeisterstrasse

**oliv-cafe.de**

After a shopping marathon in the city center, you can get a wonderful pick-me-up in this café. There is pain au chocolat fresh from the oven and cheese-cake, apple tarts, and crumb cake.

# Caras

**MITTE** Neue Schönhauser Strasse 9
U-Station: Weinmeisterstrasse

**www.caras.de**

I often pick up my coffee from this café after a session at Spirit Yoga, but the walnut bread sandwiches, fruit cups, and salads such as the grilled veggie couscous are delightful and freshly prepared daily. Caras is also a "see and be seen" kind of place; which doesn't hurt!

# Café Fleury

**MITTE** Weinbergsweg 20
U-Station: Rosenthaler Platz

A perennial favorite, particularly in summer due to the terrace that is right next to the Weinbergspark entrance. The typical French breakfast is lovingly arranged and the scrambled eggs with herbs are also good and specially cooked in a square form. You can buy French sweets at the counter. An offshoot has opened across the street: the Petit Fleury. You can nibble on tasty quiche with salad here.

# Café Buchwald

**TIERGARTEN** Bartningallee 29
S-Station: Bellevue
**konditorei-buchwald.de**

Buchwald was previously the imperial court supplier for Baumkuchen—to this day, you can still buy this unique layered cake in Berlin at this patisserie. The furnishings and the staff are delightfully old-fashioned. In summer, one can comfortably sit outside right on the river Spree and drink coffee with whipped cream!

# Café Strauss

**KREUZBERG** Bergmannstrasse 42
U-Station: Südstern
**cafestraussberlin.de**

A café in a former funeral parlor at a
cemetery is surely unusual—but in the
case of the Friedrichswerderschen
churchyard, it is unusually beautiful. In
summer, one can sit on the terrace with
a view of the graves and old trees and
enjoy a cup of Viennese coffee, a berry
torte, or a canapé with beets or eggs.
A squirrel will dart through the grass
from time to time. I have celebrated my
birthday at this small haven. The guests,
both young and old, were fascinated by
the location.

# Westberlin

**MITTE** Friedrichstrasse 215
U-Station: Kochstrasse
**westberlin-bar-shop.de**

Those who do not want to end up
at Starbucks or McDonald's after
a visit to tourist destinations like
Checkpoint Charlie or the Martin-
Gropius-Bau must only walk a
few steps up Friedrichstrasse to
land at a cool café with a great
magazine selection and many books
about Berlin.

# Café Einstein Stammhaus

**CHARLOTTENBURG** Kurfürstenstrasse 58
U-Station: Nollendorfplatz
**cafeeinstein.com**

A very atmospheric, special place
with wonderful rooms with high
ceilings and old mirrors on the walls.
The coffee house was the former
apartment of silent film star Henny
Porten. At that time, all of the famous
stars of Babelsberg lived around
Kurfürstenstrasse, Pohlundstrasse,
and Lützowstrasse. Today, artists and
galleries have moved here again.

Delectable Bites

# Berlin's Sweet Side

## Chocolateria Sünde

**KREUZBERG** Oranienstrasse 194
U-Station: Kottbusser Tor

A marvelous café where you can surrender to your chocolate addiction.

## Erich Hamann

**KREUZBERG** Brandenburg Strasse 17
U-Station: Konstanzer Strasse
**hamann-schokolade.de**

Berlin's most tradition-steeped chocolate manufacturer. Dark chocolate is their specialty.

## Parlor Sucré

**KREUZBERG** Görlitzer Strasse 32a
U-Station: Schlesisches Tor
**salonsucre.de**

Tiny French calorie bombs like éclairs and meringue tarts.

## Erste Sahne

**NEUKÖLLN** Kienitzer Strasse 116
U-Station: Boddinstrasse
**otivm.de**

A truly exclusive tip: At this magically enchanting location, one can enjoy semifreddo, babà (a specialty from Naples), or granita (a Sicilian ice specialty) by the two Roman master confectioners, Sara and Domenico.

## Philomenis

**CHARLOTTENBURG** Knesebeckstrasse 97
U-Station: Ernst-Reuter-Platz

Healthy nibbling! There are dried fruits, gourmet walnut kernels, and sweet Greek delicacies available here.

## Aseli

**REINICKENDORF** Granatenstrasse 22
S-Station: Berlin Schönholz
**aseli.de**

This Berlin family company from Pankow offers handmade candies made from marshmallow. The best white mice in the entire world (…are made of Aseli marshmallow)!

## Kado

**KREUZBERG** Gräfestrasse 20
U-Station: Südstern
**kado.de**

Licorice from mildly sweet to salty. Tip: Flip through the licorice book *Lakritz: Die Schwarze Leidenschaft* while nibbling on an assorted pound of candy.

# Summer Specials

## Prater Garten

**PRENZLAUER BERG** Kastanienallee 7-9
U-Station: Eberswalder Strasse
**pratergarten.de**

The oldest—and certainly one of the nicest—beer gardens in Berlin. I'm lucky enough to live very close by. Hans Albers was a frequent guest in earlier times. The food and drink are self-service. Home cooking and seasonal items are on the restaurant menu. My favorite dish is the Königsberger Klopse (meatballs in a caper sauce). Those with a smaller appetite may order a Prater beer, corn on the cob, and almonds for nibbling from the little hut outside. One arrives there by bike! The beer garden opens in April, but the restaurant is open year-round. Because of its close proximity to two Volksbühne theaters, one could bump into famous German actors such as Katja Riemann and Til Schweiger. In 2009, René Pollesch reopened the beloved theater next to the beer garden—Prater der Volksbühne.

# Café Schoenbrunn

**FRIEDRICHSHAIN** Am Friedrichshain 8
MetroTram M10 Torstrasse

schoenbrunn.net

The pavilion was built according to plans drafted by the Weissensee School of Art in the early seventies and is considered an important monument of East German building history. Not only the architecture but also the marvelous location at the swan pond in the middle of Friedrichshain draw Berlin women in droves. Before or after going for a wonderful walk, one should not forget to visit the fairy tale fountain, the Märchenbrunnen. Enchanting!

# Café am Neuen See

**TIERGARTEN** Lichtensteinallee 2
S-Station: Tiergarten

cafe-am-neuen-see.de

Absolutely romantic, directly on the Neuen See and situated in the middle of the Tiergarten district. The beer garden entices in the summer and winter, when you can snuggle up next to the open fire. For food, there are homemade pretzels and Leberkäse, crisp brick-oven pizzas, freshly broiled chicken, and sourdough bread from the Borchardt Bäckerei.

## *Even more tips for the Berlin summer*

# Nola's am Weinberg

**MITTE** Veteranenstrasse 9
U-Station: Rosenthaler Platz

nola.de

# Freischwimmer

**KREUZBERG** Vor dem Schlesischen, Gate 2
U-Station: Schlesisches Tor

freischwimmer-berlin.com

# Strandbar Mitte

**MITTE** Monbijoustrasse 3
S-Station: Hackescher Markt

strandbar-mitte.de

# Fischerhütte am Schlachtensee

**ZEHLENDORF** Fischerhüttenstrasse 136
U-Station: Krumme Lanke

fischerhuette-berlin.de

# Hafenküche

**RUMMELSBURG** Zur Alten
Flussbadeanstalt 5
S-Station: Berlin-Rummelsburg

hafenkueche.de

# Vegetarian Spots

Nearly everyone today knows about food allergies, and for every incompatibility there is an appropriate restaurant with a gluten-free or lactose-free kitchen. Above all, however, there are some very good vegetarian restaurants that are so tasty that they could convert even the most ardent meat lovers. The pioneers of meatless pleasures in Berlin, among others, are Heinz Gindullis, alias Cookie, who has laid the cornerstone for excellent meatless dining in Berlin with his vegetarian restaurant, Cookies Cream, as well as Björn Moschinski from the restaurant Kopps, which dishes up a brilliant cordon bleu—and it's vegan!

## Cookies Cream

**MITTE** Behrenstrasse 55
U-Station: Französische Strasse
**cookiescream.com**

Seasonal ingredients, and a club is next door—a vegetarian restaurant can be so cool!

## Kopps

**MITTE** Linienstrasse 94
U-Station: Rosenthaler Platz
**kopps-berlin.de**

Try the vegan ravioli or nut roast. So good you'll fall off your chair!

Berlin isn't all about sausages and curry!

# Chipps

**MITTE** Jägerstrasse 35
U-Station: Hausvogteiplatz
**chipps.eu**

Artful dishes for vegetarians, such as deluxe egg and potato dishes. A super lunch!

# Lucky Leek

**PRENZLAUER BERG** Kollwitzstrasse 54
U-Station: Senefelderplatz
**lucky-leek.de**

One hundred percent vegan dishes, such as beet tartare, potato cannelloni, or seitan saltimbocca can be found on the weekly changing menu.

# La Mano Verde

**CHARLOTTENBURG** Uhlandstrasse 181
U-Station: Uhlandstrasse
**lamanoverdeberlin.com**

This gourmet vegetarian restaurant is also great for gluten-free, vegan, and raw food. You must try the green smoothie with baby spinach, bananas, apples, and kiwi.

# Oh Làlà

**FRIEDRICHSHAIN** Mainz Strasse 18
U-Station: Samariterstrasse
**facebook.com/ohlala.berlin**

Among other things, there is French vegan food, vegan tarts, and Flammkuchen. Go for brunch on the weekend.

# Dirty South

**FRIEDRICHSHAIN** Krossener Strasse 18
U-Station: Samariterstrasse
**facebook.com/dirtysouthberlin**

Vegan and gluten-free tacos, nachos, and chili "sin" carne.

# Burrito Baby

**NEUKÖLLN** Pflügerstrasse 11
U-Station: Schönleinstrasse
**burritobaby.de**

The motto is "Mextralian street food" and vegan burritos are served. I like the distressed wood interior accented with leather!

## TIP

Ⅲ||||||||||||||||||||||||||||||||

On the Veggie Way blog (veggieway.de), journalist and vegetarian Julia Stelzner reviews the best vegetarian restaurants!

# Bakeries

## *The best addresses for delightful bread*

All German expats around the world yearn for brown bread—it is like a piece of home. There are an increasing number of bakeries that make their own bread, rolls, strudel, cakes, or baked goods using organic ingredients. Apart from actual shops, fantastic bread stands can be found at the Berlin weekly markets such as the Kollwitzmarkt or the Winterfeldmarkt.

# Zeit für Brot

**MITTE** Alte Schönhauser Strasse 4
U-Station: Luxemburg-Platz
**zeitfuerbrot.com**

Oh, you swear by low carb? What a shame, because in Berlin, there are delightful breads slowly baked according to traditional methods. Zeit für Brot is a persuasive concept: Craft meets science meets modern café culture. I would say this is what the bakery of the future looks like. The whole wheat bread, raisin rolls, and yeast buns with maple walnuts count among my favorites. You can easily share a treat with your best friend. This keeps you thin but happy!

Soluna – Brot und Öl

# Soluna – Brot und Öl

**KREUZBERG** Gneisenaustrasse 58
U-Station: Südstern

The big stone oven is not only a decoration—possibly the best brick oven–baked breads in the city are made in it. The house specialty is Rundling, a four-pound-heavy sourdough bread. The black whole-meal barley bread known as Ostblock is also fantastic. The quality is extraordinary in comparison to bland supermarket bread. A piece of cheese, a sausage, and a couple of tomatoes with this crusty loaf and a delightful German dinner is ready!

# Mehlstübchen

**SCHÖNEBERG** Leberstrasse 28
S-Station: Julius-Weber-Brücke
**mehlstuebchen.de**

The Berlin woman loves DIY! With qualified baker Nicole Kamrath, you can buy bread or all of the ingredients to do your own baking: baking mixtures or various freshly ground types of flour, such as French brioche flour, gluten-free rice flour, or Ethiopian teff flour, which is a type of millet. The stollen mix is terrific for Christmas.

# Manufactum
# brot & butter

**CHARLOTTENBURG** Hardenbergstrasse 4-5
U-Station: Ernst-Reuter-Platz
**manufactum.de**

Here, you can enjoy delightful sourdough bread with Odenwald butter. The bread is very fresh and is baked according to the Slow Food principle, in stoves made of Eifel tuff stone.

# Bäckerei
# Alpenstück

**MITTE** Gartenstrasse 9
U-Station: Nordbahnhof
**alpenstueck.de**

This bakery uses typical south German bread seasonings such as cilantro seed and aniseed—the bread is absolutely wonderful and pairs perfectly with soups or cheese. There is a shop across the street where you can stock up on homemade soups in glass jars.

# Wiener Brot Holzofenbäckerei

**MITTE** Tucholskystrasse 31
U-Station: Oranienburger Strasse
**wienerbrot.de**

Sarah Wiener is not only a noted cook, TV star, and writer, but also an important Berlin gastronomic entrepreneur—she stands for honest cooking without frivolity. Pure sourdough rye bread and small baked goods such as kaiser rolls and Austrian butterstangerl are available for purchase in her bakery. The large, flat loaves have a particularly nice crust and are seasoned with cilantro, aniseed, and fennel—typical to the Alpine country. They are baked in the Neukölln area, in a stone stove fueled with Brandenburg robinia wood. Sounds delicious, right? It definitely is!

# Malin Elmlid's Bread Exchange

**www.thebreadexchange.com**

No food is better shared than bread. In 2009, Malin Elmlid developed a project called "The Bread Exchange." The Swede bakes delicious sourdough bread and, rather than selling it, exchanges a loaf for one hour of guitar lessons, vanilla from Madagascar, home-churned butter, or a bicycle repair—whatever her counterpart has to offer. I think the idea is a perfect fit for Berlin. Alongside the best types of flour, Malin Elmlid also uses unusual ingredients such as beer, ash, dried apricots, nuts, or herbs—but no yeast.

# Bars

## Victoria Bar

**TIERGARTEN** Potsdamer Strasse 102
U-Station: Kurfürstenstrasse
**victoriabar.de**

I am a loyal soul—Victoria Bar was one
of the first really good bars in Berlin. It
is still worthwhile to go there, particu-
larly since the area all around Potsdamer
Strasse is booming. The bar is very
lively, the drinks and the service are
good, and above all, the bar food is
superb. While you are there, the world
outside the door is forgotten.

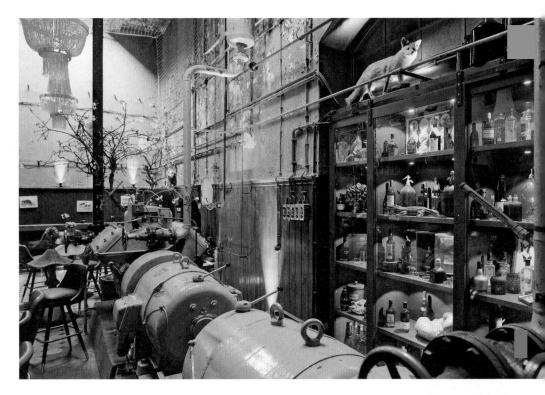

# Le Croco Bleu

**PRENZLAUER BERG** Prenzlauer Allee 242
U-Station: Senefelderplatz

lecrocobleu.com

Gregor Scholl of the Rum Trader (p. 218) has opened a second, outstanding bar in the vaulted cellar of the Bötzow Brewery. During the Second World War, two crocodiles were supposedly brought there from the zoo for safety—hence, the name. All the same, the drinks are wonderful.

# Buck & Breck

**MITTE** Brunnenstrasse 177
U-Station: Rosenthaler Platz
**buckandbreck.com**

The entrance is inconspicuous and easy to miss, but for me, Buck & Breck is the best bar in Berlin. Everything here is simply right: The barkeepers master their craft and talk no nonsense; the music is good and is at exactly the right volume so that you can still chat and relax. It only receives as many people as there are bar stools. Fourteen, to be exact. What connects the guests? Everyone is keenly focused on a good drink.

# Rum Trader

**WILMERSDORF** Fasanenstrasse 40
U-Station: Spichernstrasse

The owner, who opened this rum-specialized mini-bar in the city center in the seventies, was the favorite barkeeper of the James Bond creator, Ian Fleming. Not much has changed since then in terms of the interior decor, but the drinks are known citywide. The guests are looked after personally by Gregor Scholl, who always appears in a vest and bow tie. My cocktail is the Maharani. There are no mainstream drinks like Caipirinhas here!

# Not tired yet?

## *Then have a nightcap!*

### Drayton Bar

**MITTE** Behrenstrasse 55
U-Station: Französische Strasse

draytonberlin.com

One of the clubs by Berlin nightlife icon Heinz Gindulli, a.k.a. "Cookie."

### Neue Odessa Bar

**MITTE** Torstrasse 89
U-Station: Rosenthaler Platz

neueodessabar.de

A smoker's bar; the entire city center meets here.

### Tier

**NEUKÖLLN** Weserstrasse 42
U-Station: Rathaus Neukölln

Neukölln hums, and this bar on the Weserstrasse pub mile is always full.

### King Size Bar

**MITTE** Friedrichstrasse 112 B
U-Station: Oranienburger Tor

kingsizebar.de

Drink a Moscow Mule (vodka, ginger ale, and cucumber) and dance.

### Bar Tausend

**MITTE** Schiffbauerdamm 11
S-Station: Friedrichstrasse

tausendberlin.com

Two words: Raspberry mojito!

### Bar 3

**MITTE** Weydingerstrasse 20
U-Station: Luxemburg-Platz

Kölsch is on tap here—a super nice bar!

### Möbel Olfe

**KREUZBERG** Reichenberger Strasse 177
U-Station: Kottbusser Tor

moebel-olfe.de

Known as the Trinkhalle (drinking hall), this is a popular gay and lesbian bar.

### Ankerklause

**KREUZBERG** Kottbusser Damm 104
U-Station: Schönleinstrasse

ankerklause.de

A former boathouse turned bar on the river Spree.

### Bierstube Alt Berlin

**MITTE** Münzstrasse 23
U-Station: Weinmeisterstrasse

A grungy, wood-paneled Berlin classic.

LUSTROUS TRADITION: Hotel in the thirties style

# ALMOST LIKE HOME

**The best Berlin hotels, summer cottages, and apartments—and sightseeing tips for what to visit while you are staying there.**

The five-star classics in Berlin offer luxury and comfort, but not necessarily much Berlin flair. I like the old, typical Berlin pensions much better. Some are housed in fashionable old apartment buildings in West Berlin, with high ceilings, a great deal of stucco, and creaking parquet flooring. Many are still very inexpensive! In addition to my list of hotels, take advantage of more insider travel knowledge when planning a trip to Berlin with the advice to be found on some of my favorite websites, which are full of suggestions on what to do.

Hotel Classics 222
Hotels en Vogue 224
Berlin's Best Websites! 229

# My Hotel Classics

## Askanischer Hof

**CHARLOTTENBURG** Kurfürstendamm 53
S-Station: Savignyplatz
**askanischer-hof.de**

The Askanischer Hof in the heart of Kurfürstendamm still exudes the magic of the roaring twenties. David Bowie, Arthur Miller, Robert Wilson, Michel Piccoli, and Tilda Swinton have all slept at this hotel. Nan Goldin has taken many of her noted photos here. The photos in the breakfast room testify to the vast number of prominent artist guests. There are sixteen individually furnished rooms.

## Savoy

**CHARLOTTENBURG** Fasanenstrasse 9
U-Station: Zoologischer Garten
**hotel-savoy.com**

Thomas Mann stayed overnight at the historically significant four-star Savoy hotel and described it as "congenial and comfortable." Many other illustrious guests have stopped here, like Maria Callas, Romy Schneider, Herbert von Karajan, and Helmut Newton—it was his favorite hotel. The Helmut Newton Foundation that the legendary photographer founded in 2003 before his death lies just around the corner at the Bahnhof Zoo train station.

## Pension Funk

**CHARLOTTENBURG** Fasanenstrasse 69
U-Station: Uhlandstrasse
**hotel-pensionfunk.de**

In my opinion, the Pension Funk lies on the loveliest street in Berlin: Fasanenstrasse. The then-famous silent film star Asta Nielsen once lived in the huge house.

## Nürnberger Eck

**CHARLOTTENBURG** Nürnberger Strasse 24a
U-Station: Wittenbergplatz
**nuernberger-eck.de**

Nürnberger Eck is very comfortably appointed with pieces of furniture from the twenties and wallpaper from the thirties. But, there is also WiFi! From actor Gert Fröbe to British punk bands in the 1980s, this pension has experienced a thing or two.

# Hotels en Vogue

## The Stue

**TIERGARTEN** Drakestrasse 1
U-Station: Zoologischer Garten
**das-stue.com**

This luxurious boutique hotel with eighty rooms in a historically listed 1930s building lies in the middle of the zoo. You can look directly into the animal enclosures of the Berlin Zoo and so even staying there a single night is worth it. The Spanish designer Patricia Urquiola has furnished the extremely cozy lounge in which you can relax with a cup of tea or hold an important meeting.

# Soho House Berlin

**MITTE** Torstrasse 1
U-Station: Luxemburg-Platz
**sohohouseberlin.de**

In my experience, this is one of the most beautiful properties within the exclusive Soho club and hotel chain. It not only has the perfect location and a tumultuous, typically Berlin history (initially the Jonass department store, then the Hitler Youth headquarters, and then the SED Politbureau), but it also has very beautifully furnished rooms. The spa, the club, and the restaurant are also highly recommended.

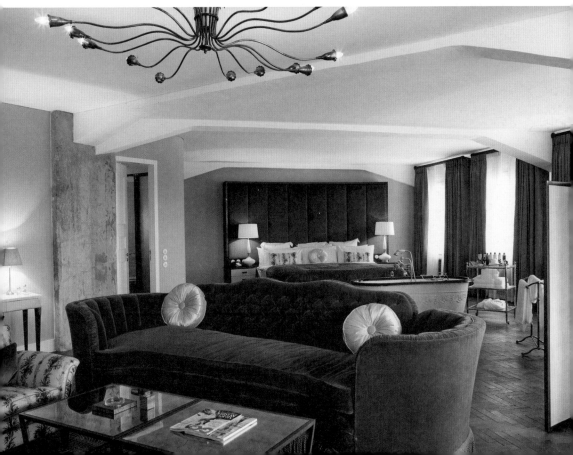

# Amano Mitte

**MITTE** Auguststrasse 43
U-Station: Rosenthaler Platz
**amanogroup.de**

The fantastic location in the middle of the city center is reason enough to settle into the Amano, but the lavish lobby and the lovely rooms at reasonable prices seal the deal. In particular, the rooms that reach out to the back of the Alten Garnisonsfriedhof (cemetery) have a special flair. In summer, the bar on the roof is a meeting place for revelers; otherwise, the smoker's bar is very hip.

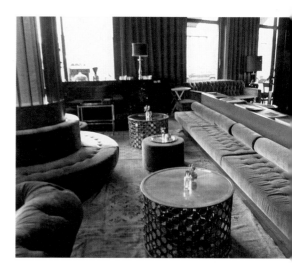

# Tautes Heim

**NEUKÖLLN-BRITZ** Gielower Strasse 43
U-Station: Parchimer Allee
**tautes-heim.de**

The Tautes Heim is situated in the well-known Horseshoe Estate by Bruno Taut in Britz, south of Neukölln. The summer cottage with three rooms was lovingly restored down to the smallest detail. A first-class architectural experience, not just for design fans!

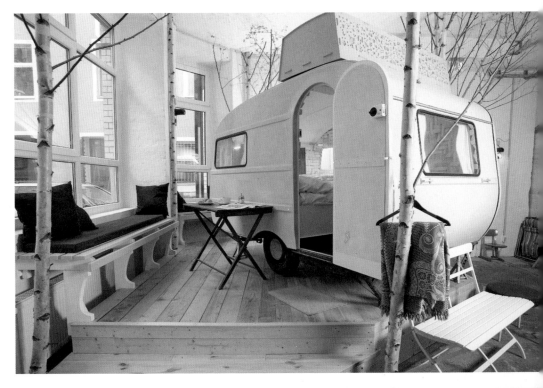

# Hüttenpalast

**NEUKÖLLN** Hobrechtstrasse 65-66
U-Station: Hermannplatz
**huettenpalast.de**

Germany's love of camping finds ample
expression here. Lovingly restored
vintage caravans from East Germany
and cottages built by hand can be found
in an old factory building. It also has a
terrific café and small garden.

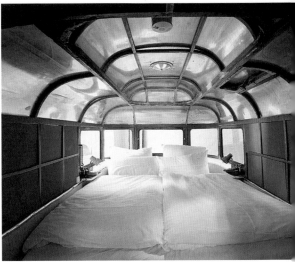

# Michelberger Hotel

**FRIEDRICHSHAIN** Warsaw Strasse 39/40
U-and S-Station: Warsaw Strasse
**michelbergerhotel.com**

The look of a typical Berlin apartment
share is mixed with international atmo-
sphere at the Michelberger. A former
industrial building was transformed into
a hotel with 119 rooms. Responsibility
for the interiors was taken on by Werner
Aisslinger, one of Germany's most
prominent designers, whose works
can also be seen at the MoMA. The
restaurant and the bar are the meeting
place for a hip, international crowd of
young people.

# Additional addresses

berlincribs.com
brilliant-apartments.de
boxhagener-hoefe.de
flowersberlin.de
grenzjosef.de
miniloft.com
sanktoberholz.de
schoenhouse.de
winterfeldt10.de

# Booking sites

9flats.com
airbnb.de
ahomeinberlin.com
coming-home.org
boutique-homes.com
city-wohnen.de
justbook.com

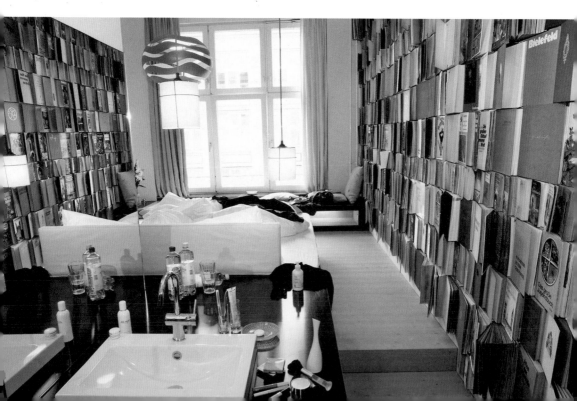

Site-seeing
# Berlin's Best Websites!

## 1. berlinreified.com

How does one spend a nearly perfect day in Berlin and Brandenburg? This food blog not only offers culinary forays, but also makes a great number of suggestions for the rest of the day!

## 2. findingberlin.com

The network of authors finds even the smallest Berlin gems, whether they be deserted gardens in Neukölln or the hippest bars in the Nikolaiviertel area at night.

## 3. iheartberlin.de

A personal blog by a Berlin woman for city dwellers who are on the hunt for the "real" Berlin.

## 4. ligastudios.com/ berlin

Bars, clubs, food, hotels, culture, shops, and exclusive tips—you can read up on all the Berlin highlights here, whether it is Marie Grönemeyer's (yes, Herbert's daughter) Ø Restaurant, the Bäckerei Wiener Brot, or the Prince Charles Bar.

## 5. nicheberlin.de

Sightseeing for insiders: Art historians Stefanie Gerke and Nele Heinevetter, as well as the architect and monument conservator Katharina Beckmann, reveal art and architecture in Berlin that is off the beaten tourist paths.

## 6. slowtravelberlin.com

"Less is more" is also a valid motto for a weekend in Berlin. One need not see EVERYTHING. It's better to hand-pick a few choice spots and enjoy them— for example, a district walk through Wedding or Prenzlauer Berg.

## 7. sugarhigh.de

A German or English e-mail magazine that reports on everything that is hot in Berlin: art, music, fashion, food, movies, and last but not least, parties!

## 8. uberlin.co.uk

Did you know about the Buchstabenmuseums (Museum of Letters)? How does a pug named Olive enjoy a spring day in the capital? You will find such tips and stories on this blog.

# BERLIN WOMEN

## Sandra Semburg

This fashion, portrait and street style photographer is a native-born Berlin woman. At nineteen she moved to New York, where she discovered her love of photography during her studies at the Lee Strasberg Institute. Among other things, a study in film and an assistant position with the famous fashion photographer Greg Kadel followed. These days, she is living in Berlin once again where she has photographed actresses such as Sibel Kekilli and Iris Berben. *Grazia*, *InStyle*, *P&C*, and Vogue.com are among her clients. Her photos of international fashion shows can be viewed on her fashion blog aloveisblind.com.

## Angelika Taschen

Born into a family in the book trade, Angelika Taschen completed her doctorate in art history and German studies at the University of Heidelberg in 1986. She is a globally respected design and lifestyle expert and has published more than 150 books on design, fashion, art, photography, and architecture. Moreover, she consults with companies on strengthening their brands and develops blogs. After various stays at home and abroad, she has been a loyal Berlin woman since 2004.

## Melanie Petersen

Melanie Petersen was born in Husum and studied in Hamburg, after which she came to Berlin as a graphic artist for the development and launch of the German *Vanity Fair*. After positions as a graphic artist with the art magazine *Monopoly* and a few months in New York, she strengthened the design team at the Axel Springer Publishing House, where she was art director of the "WELT SUNDAY" until summer 2012. Melanie Petersen currently is a freelance art director and illustrator and lives in Berlin. She founded the PETERSEN label last year (hellopetersen.com), an online concept store.

## Alexa von Heyden

The fashion journalist, blogger, and entrepreneur Alexa von Heyden was born in Bonn in 1978. She studied fashion journalism at the Academy of Fashion and Design (AMD) in Hamburg and later completed her Master of Arts in cultural journalism at the Berlin University of the Arts. Alexa von Heyden has written for many well-known magazines and newspapers, such as FTD/howtospendit, *Stern*, *InStyle*, and *Vanity Fair*. Her blog is called Alexa Bang and she is also an author with Journelles.de, one of the most influential German fashion blogs. In 2007, Alexa von Heyden established her own jewelry label, vonhey, in Berlin. Her debut novel *Hinter dem Blau* was published in 2013.

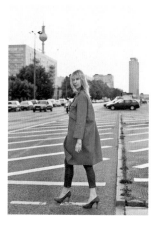

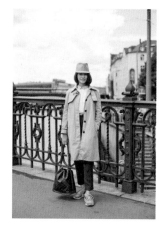

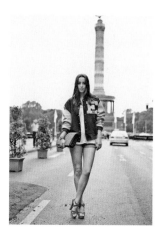

**PAGE 2**: Angelika Taschen on Karl-Marx-Allee in her favorite red coat by Jil Sander.

**PAGE 4**: Emmy Urbane, responsible for the KISS/Fiona Bennett brand, on Friedrichstrasse in Schiffbauerdamm.

**PAGE 8**: Model Doreen Schumacher, who designs under the parka label Around Corner.

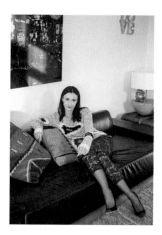

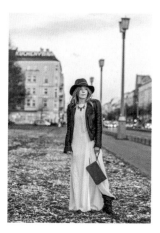

**PAGE 35**: Fashion journalist and blogger (spruced.us) Marlene Sørensen.

**PAGE 36**: Anita Tillmann, founder of the fashion exhibitions "Premium."

**PAGE 39**: Fashion designer Malaika Raiss (malaikaraiss.com).

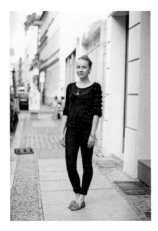

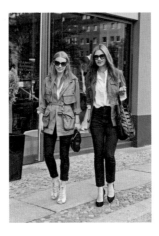

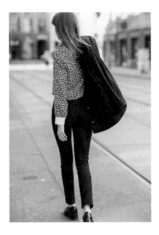

PAGE 28: Dana Roski, Wald concept store partner.

PAGE 31: Johanna Kühl and Alexandra Fischer-Roehler, designers of the Kaviar Gauche fashion label.

PAGE 33: Almut Coppius is an architect, designs her own handbags, and works at the Acne store.

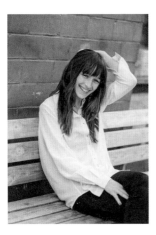

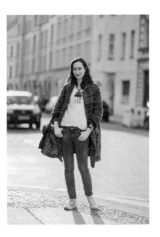

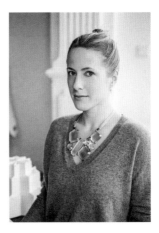

PAGE 41: Designer and cofounder of the Mongrels in Common and Livia Ximénez-Carillo fashion labels.

PAGE 42: Fashion expert and journalist Pia Sundermann.

PAGE 58: The coauthor of this volume: Alexa von Heyden.

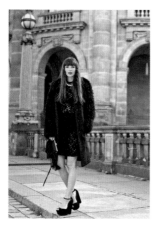 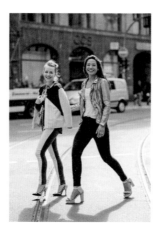 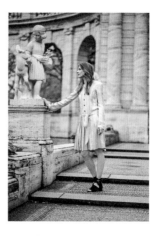

PAGE 68: Model Eva-Maria Kaiser on Berlin's Museum Island.

PAGE 79: Dana Roski and Joyce Binneboese, the two owners of the Wald concept store.

PAGE 99: The fashion expert Julia Freitag at the fairy tale fountain in Friedrichshain.

# Acknowledgements

**Illustrations: © Melanie Petersen**
Pages 12, 16, 19, 29, 46, 51, 55, 59, 63, 70, 73, 74, 83, 113, 129, 139, 149, 159, 161, 177, 179, 205, 211, 215, 221, 236, 239

**Photos: © Sandra Semburg**
Pages 2, 4, 6–7, 8, 28, 31, 32–33, 35, 36, 39, 41, 42, 44, 47, 48–49, 50, 52–54 (except 53 bottom), 56–58 (except 57 top), 60–62 (except 61 bottom), 64–68, 79–80, 82–93 (except 87 bottom, 92 bottom), 95 top, 99–100, 101 top, 108–110, 123, 124 top, 127, 136–138, 148, 151 bottom, 152–153, 174–176

**© Angelika Taschen**
Pages 53 bottom, 94, 95 bottom, 102–103, 129, 143, 150, 154–155, 163 bottom, 164, 165 right, 167 top, 168, 169 bottom, 170 top, 171, 181 top, 183 bottom, 185, 186 top, 187 bottom, 188, 189 top, 190, 194–199, 200 bottom, 201–203, 204 top, 206–207, 213, 214 top and middle, 218, 222–223, 226 top right.

**We thank the following companies for supplying the following copyrighted © photos:**

Page 57 top, Owl Design; page 61 bottom, Cada; page 87 bottom, Voo Store; pages 92–93 bottom, Mongrels in Common; page 101 bottom, Lunettes-Selection; page 104, KaDeWe/The Loft; page 122, Jacks Beauty Department; page 124 top right and bottom, MDC Cosmetics; page 125 top, Soho House, Berlin / Cowshed; page 125 bottom, Schöne Mitte; page 126, Birga Hauptmann; page 128 top, Salon Max Höhn; page 128 bottom, Wolfgang Zimmer; page 130, Frau Tonis Parfum; page 131, J. F. Schwarzlose; pages 133 and 135, Spirit Yoga, Berlin; page 151 top, Villa Hartneck; page 156, Bücherbogen am Savignyplatz; pages 160 and 163 top, Objets trouvés; page 162, Appel Design Gallery; page 165 top left, Neue Tische; page 166, Hans-Peter Jochum; page 167 bottom, Jan Kath, photo by Attila Hartwig; page 169 top, Süper Store; page 170 center, Park Haus; page 170 bottom, Paper and Tea, photo by Ludger Paffrath; page 180, Grosz; page 181 bottom, Borchardt; page 182 top, Grill Royal, photo by Lepkoski Studio; page 182 bottom, Pauly Saal, photo by Stefan Korte; Page 183 top, Restaurant Tim Raue; page 184 left, La Soupe Populaire; page 184 right, Mogg and Melzer Delicatessen; page 186 bottom, Lokal; page 187 top, Pappa e Ciccia; page 189 bottom, Die Henne Berlin, photo by W. Chodan; page 200 top, Princess Cheesecake, photo by Katy Otto; page 204 bottom, Café Einstein; page 210, © Mirjam Wählen; page 212, Zeit für Brot, photo by Tino Pohlmann; page 214 bottom, Bäckerei Alpenstück; page 216, Victoria Bar, photos by Kerstin Ehmer, Katja Hiendlmayer; page 217, Croco Bleu; pages 220 and 224, Das Stue; page 225, Soho House, Berlin; page 226 bottom, Tautes Heim; page 227, Hüttenpalast; page 228, Michelberger.

And a special thanks to Marlene Sørensen for the photograph on page 230.

Notes

Notes

German-language edition design by Leonore Höfer

# ABRAMS IMAGE EDITION

Translated from the German
by Mary Harris and Henning Grentz

Editor: Laura Dozier
Designer: Shawn Dahl, dahlimama inc
Production Manager: Erin Vandeveer

Library of Congress Control Number: 2013945685
ISBN: 978-1-4197-1257-9

Printed and bound in China
10 9 8 7 6 5 4 3 2 1

Abrams books are available at special discounts when
purchased in quantity for premiums and promotions as
well as fundraising or educational use. Special editions
can also be created to specification. For details, contact
specialsales@abramsbooks.com or the address below.

THE ART OF BOOKS SINCE 1949

115 West 18th Street
New York, NY 10011
www.abramsbooks.com